Flesh & Spirit

VOLUME VI

Flesh & Spirit

21st: The Journal of Contemporary Photography

Edited by John Wood

Published by Steven W. Albahari

THIS VOLUME OF *21st* HONORS AND CONGRATULATES

Dana Gioia,

a friend for many years,

who, as we began work on this issue,

was unanimously confirmed

by the United States Senate

as Chairman of the National Endowment for the Arts.

In an essay on "The Recovery of the Beautiful"

in the first volume of this journal he wrote these wise words:

There are—in general terms—two conceptions of beauty currently

available in our culture. The first notion . . . is that beauty is a social

construction. What any culture considers beautiful, this theory insists,

is a complex reflection of its own values (and usually the specific values

of its ruling classes). . . . The other notion of the beautiful is that it

exists largely independent of political or social agency. The standards of

beauty are not created but recognized. Cultures may differ slightly in

their articulation of the beautiful, but underlying the local accents there is

always a strong sense of universal human values. . . . In this theory the

ultimate source of beauty is the totality of the natural world—a unity

of which humanity is part. The shape and rhythms of nature deeply

determine our ideas of the beautiful. Humanity does not endow a flower

or waterfall with beauty; instead, beauty is the cognitive exhilaration

that comes from recognizing the rightness and form of the object.

Table of Contents

List of Photographers

Editor's Statement

Volume VI of *21st, Flesh and Spirit*, brings together many of the greatest contemporary photographers with many of the finest novelists, playwrights, poets, historians, and critics writing today. *Flesh and Spirit* is a celebration of the things of earth, the things of heaven, and their intersection. Look at Toni Catany's *El Beso* (The Kiss); is the Flesh kissing the Spirit or is the Spirit kissing the Flesh? It is difficult to tell—as difficult as the spirit is to know—even for mystics. More often than not, they have come to it through the body. Consider that rapturous, clearly sexual look Bernini placed on the face of his *St. Theresa in Ecstasy*; consider her own words, her impassioned record of a deeply physicalized mystical experience. Is any of this surprising? Is it not through the body of Nature, through our flesh and the things of this world alone, that the spirit is revealed and we begin to recognize it and know it? Look at S. J. Staniski's photographs of the mosques of Bani, images that take us to spiritual places, but then read Robert Olen Butler's words inspired by those photographs and see how he weaves a narrative, a prose poem, about those places that shockingly, jarringly, immediately takes us back to the body, to the flesh, which in its final transcendent seconds realizes "that heaven is simply a shaping of the earth."

This issue opens with new work by Flor Garduño, one of the most deeply physical of contemporary artists. Her great subjects are the body and the spirit. I've loved her work for years, and I originally began my essay saying she is one of the greatest living female photographers. And then I stopped myself. I hate this very kind of bracketing of art and artists. The academy is dominated today by those who want to consider not art but the art of women, of gays, of Blacks or of any marginalized people. As a passionate and lifelong leftist, I am deeply sympathetic to such politics. But art, as even

Leon Trotsky stated, is not about politics; it is about aesthetics. When we draw any kind of demarcations on art but artistic demarcations, we trivialize the politics we espouse and show little understanding of what art is actually about or from where it springs. In a recent interview in *Contemporary Poetry Review* (February 22, 2003) Dana Gioia stated, "Art is an affair of individual genius and a passionate dedication to the highest standards. It is not an affair of institutions and ideologies."

Gioia continued: "What matters is not political allegiance but a stubborn determination to get at the truth rather than merely acquiesce to the currently popular platitudes." He goes on to talk of poetry, but I am going to insert the word *art* where he used *poetry* because what he says is equally applicable to art in general. "To judge art as political speech is to misunderstand it on the most basic level. Art is not primarily conceptual or ideological communication. It is a different way of knowing—experiential, holistic, and physical—that is largely intuitive and irrational. To treat art as political statement reduces a complex and dynamic thing to a few predetermined categories. No wonder the urge to politicize art proves irresistible to the ignorant, the lazy, and the small-minded of all persuasions."

It is in and through art that we find the only true brotherhood and sisterhood of humanity. Art is what truly brings us all together—regardless of our political, religious, ethnic, national, regional, social, sexual, or biological allegiances. It can do this because it speaks to the one great emotion we can all share in common—that powerful, overwhelming, life-enhancing joy that art can give to all of us—regardless of how we vote, pray, or have sex.

The art of this issue, both the images and the words, are as beautiful as they are intellectually challenging, but too often we, especially the academics among us—and I, too, am one—lose ourselves in the intellectual challenge, in abstraction, in irrelevant

distinctions about humanity, and in things too far from beauty, from emotion, and from art's great gift of joy. I would hope we can always keep in mind what Susan Ludvigson had to say in the beautiful poem "Phantoms," which she wrote for this issue. She perfectly articulated what I wanted to do in putting together this collection of images and writings on *Flesh and Spirit*:

here is the shimmering world
within the world.

Friends, let us not be immune
to delight.

—JOHN WOOD

Publisher's Statement

As we prepare to go to print for this, our seventh year and sixth volume of the journal, I pause, once again, to reflect on our mission to create the finest produced literary and photographic publications in the world and what that means to us and our customers.

After the shock of recently hearing that two of the major photographic equipment producing companies in the world will no longer produce film cameras after 2005, I can only anticipate the increasing unavailability of traditional film, paper and chemicals in the near future. With the advent of super technology and the voracious appetite of society for speed and instant gratification, the things of the past are receding quickly into the shadows.

So, I am gratified when customer after customer, photographer after photographer, writer after writer, comment on and share with us their great enthusiasm for producing books as was done 100 years ago. There is no coincidence here, and the credit goes to those that appreciate the present while acknowledging the past, knowing that a myopic focus on the future brings with it an existence without enduring gratification. The object that is made with the hand and with handmade materials is organic. The common thread with all of us is that it lives and breathes just as we do. Our relationship to it becomes something beyond words and is different for each of us. The making of the book and it as an object become art itself.

The celebration and joy of our art is, then, articulated by all those wonderful and talented voices and eyes within our covers. Thankfully, the art of fine writing hasn't

changed to the degree where a machine can now have a part in the creative process, and there are still photographers to be found devoted to traditional photographic processes of the past while integrating the past into the present and the future. Yes, their processes depend on technology, albeit old, but only to the degree to which it helps to convey and articulate their passions, their hearts and their truths— these come first, the tools come second. And it is this that draws the most poignant distinction between *21ST* and much of what else exists in publishing today. So, with thanks to our craftsmen, collectors, writers and photographers, *21ST* and its publications are carried into the future, ever so mindfully with eyes wide open.

—STEVEN ALBAHARI

Toward Omega

after photographs by Vincent Serbin

BY DANIEL WESTOVER

This is no repair of rotten flesh,

no sealing up where worms have burrowed,

no ashes sifting back to whole.

This is not a quickening of limbs

like in that stone-dimmed tomb, where God

threw back His burial sheet.

Nor is this some celestial excavation,

distant and trumpeted

through Armageddon's blood-soaked soil.

This is living flesh transcended by the mind,

imagination peeling back the skin

till the spirit rises on new wings.

Once, you walked on bristled hands,

dug through the slick length of vines

for roots and beetle grubs.

At night, you lay on your back,

looked through a roof of leaves, to where

blue myna birds leapt from limbs

and angled wings in the dusklight.

The weave of branches was a cage

that kept you from the moon,

and you crawled behind a rock,

shut your eyes to dull the light,

rubbed your ears with fistfuls of mulch

to block the mocking songs of birds.

As you writhed there, snatching

at twigs, pebbles, and moss,

emotion moved the mind,

and behind your pinched lids,

you saw your body melt away,

saw yourself winged and rising.

That night, in imagination's woods,

all things escaped their cages:

the tight-winged moth

wriggled from a sticky chrysalis,

the tree snail sloughed its shell,

and bald birds crashed from their eggs.

Above the trees, the moon, too,

fell from its frame,

fell toward your opened eyes

as soft light settled through the leaves.

That moon was a seed

dropped in your mind's soil,

and it shot roots, branched in you,

tightened your spine like lightning.

Your back wrenched straight,

pulled palms from the ground.

Stiff hairs fell from your pores

like dried pine needles, and you knew

sure as your new smoothness,

sure as your erect back,

that imagination had offered you its fruit,

that visions planted in your mind

would grow toward the splitting of your husk.

The years you've hurried vertical,

arms swinging at your side,

you've never let your flesh forget

that primal change, that shift of skin,

that promise of escape.

Tonight, what you have long seen

sharpening itself behind your eyes

seizes you, pulls each tendon taut,

locks the hip's hinge shut.

Teeth spill from your lips,

your jaw grinds tight, dissolves,

and your marrow cracks and powders

till your stretched flesh snaps from its frame,

and your spirit rises clear as blown glass.

Unbound, weightless as wind,

you look down at the face

gone featureless, your carcass

slumped lifeless in the dirt.

Scraps of ligament and bone

ignite as moonlight

falls unfiltered through you,

and you hover a moment

above the spent flesh

before you turn toward the moon,

the light, the imagined end.

Flor Garduño's Worlds of Wonder

BY JOHN WOOD

Flor Garduño is most well-known for her intense, deeply moving images from Latin America and her elegant but erotic nudes. The most distinctive quality of her work is its genuine freshness. It is the mark of a great artist to be able to look at what we all know and have seen yet give us something new, something we have never seen before. To be able to do it with the nude and with native peoples, two of the most overworked and, therefore, most difficult subjects in photography, demonstrates not only genius but an inventiveness seldom encountered. Most photographers do not see through their own eyes but create work that looks like the work of other photographers. They may possess considerable technique and craft, but what is missing is a distinct style, a singular voice, an original vision. Seeing with one's own eyes is one of the most difficult tasks for any artist but especially the photographic artist because every photographer's head is filled with tens of thousands of photographs she or he has seen. The question is how one can see afresh in the midst of so much visual clutter—wonderful clutter, of course—Le Gray, Le Secq, Watkins, O'Sullivan, Coburn, Kühn, Weston, Sudek, Hosoe, Witkin, and on and on—but clutter none-the-less. There is, of course, no easy way to discover or shape an original Vision. That is the gift no teacher can give.

Most photographers, most doctors, most auto mechanics, lawyers, bank tellers, and so forth are no more than average; that's what average means—where most people are. They just manage to get by; they're mediocre. *Mediocre* sounds like a harsh indictment of most photographers, doctors, mechanics, lawyers, and bank tellers, but what the

word literally means in Latin, "half way (*medius*) up the mountain (*ocris*)," is where they are. A few are above average and possess great skill, great technique, great ability—the things a good teacher can teach an artist, a doctor, a mechanic. But only a very, very few are truly inspired, possess a real Vision, a true genius, and can see something beyond the mere photography, medicine, or mechanics of the thing. Alexander Pope called it "the grace beyond the reach of art."

That is the grace Flor Garduño possesses. Though it has been more than a decade I can vividly remember the first time I saw certain images of hers and how powerfully they affected me: the woman holding the iguanas in front of her; the close-up of the boy with the strange animal mask; the man going down a street with a small coffin on his back, a man walking beside him with a shovel; the bare-breasted woman with bound iguanas beside her; the man riding the cloth and wooden turtle; the girl with the basket of bright lilies on her head. Great art is unforgettable; that is why it's great. You continue to think on it as time passes. And as time passes, it continues to grow. W. B. Yeats' "Who Goes with Fergus" is a far greater poem to me now than when I first read it, as is Brahms' Third Symphony, or Franz Marc's *Blue Horse*—or those very images of Garduño's I just mentioned.

When her book *Inner Light*, a book primarily of nudes, appeared, I knew I was seeing something essential about femininity—about Woman's beauty, her sensuality and mystery—something I knew, had seen in paintings, encountered in a few writers, but had never before seen in the work of any photographer. This is not to say that other photographers had not captured something uniquely female in their nudes—especially Stieglitz, whose images of O'Keeffe certainly capture the chthonic terror and power of the female, and frighten me a little, too. It is just to say that what Flor Garduño captured was unique, fresh, original, but every bit as true. Her images, unlike Stieglitz's,

however, are about the heavy scent of flowers, of warmth, warm light, dreaming, and invitation. Of photographers of the male nude, it is only Toni Catany who catches that same voluptuous world. This is Baudelaire's world of *Luxe, calme et volupté,* the world of *"L'Invitation au voyage"*:

> *Les soleils couchants*
> *Revêtent les champs,*
> *Les canaux, la ville entière,*
> *D'hyacinthe et d'or;*
> *Le monde s'endort*
> *Dans une chaude lumière!*

> *Là, tout n'est qu'ordre et beauté,*
> *Luxe, calme et volupté!*

> The setting sun
> Clothes the fields,
> Canals, the whole town
> In hyacinth and gold;
> The world slumbers down
> In the warm light's hold.

> There, all is beauty in perfect measure,
> Luxury, calm, and pleasure.

I recently had the pleasure of finally meeting Flor and sitting down with her for some three hours looking at new work. I thought I knew the world of Flor Garduño—the

nudes and the images of Latin America—but there are whole worlds of her work I had never seen—or even guessed existed.

There was a world of hands, one of anatomical models, another of Polish folk art, another of children's toys, and a deeply affecting one of toys in snow. Once again she had found the Vision to do something fresh and absolutely new; surrealist minimalism it might be called. We've all seen spare pictures before, but not like this! The very idea of all those baby heads—an absolutely baroque element—is antithetical to what we usually think of as minimal art, though the picture is indeed minimal. The babies look out from their barren stalks like ghosts—ghosts of the hydrangeas, perhaps? The little horse in its vast field of white must also "think it queer" to have stopped here. And he does seem in motion as if

> He gives his harness bells a shake
> To ask if there is some mistake.
> The only other sound's the sweep
> Of easy wind and downy flake.

Garduño's world of snow and toys might bring to mind Robert Frost's horse or flower-ghosts or simply child's play. I could easily imagine Flor's young daughter, Azul, having put those little heads out in the snow—children often do things that appear strange to adult eyes because children have their own logic. And I could certainly imagine her having left a toy horse in the snow, especially since they live in Switzerland. These are photographs of whimsy, but Garduño's whimsy takes a decidedly different turn in much of her other new work—a turn toward wonder, but a world of disconcerting wonder.

Works like *Visiones* with its alligator looking at the birds, *La Fortuna*, which means "Luck" and presents a leg and grapes, and *San Juan*, the strange skull-headed saint, are all images of wonder. They are three of Garduño's most affecting images, but they, like much of the new work, are strange in ways none of her previous work was. Her work has always been strange in a variety of wonderful ways because it is always full of surprises, but this is a new strangeness and it is disconcerting. I can sense the whimsy, the playfulness, but I also sense something very serious at work here, as well. When I look at *Visiones*, I am not sure if I should smile and be amused or simply be frightened. The same is the case with the photograph of *Luck*. I am, however, quite sure that *San Juan* is a powerful and potentially terrifying saint. I would not risk smiling at him, but I would trust any saint that looked like him with a prayer. He is obviously magical. He, of course, is related to Garduño's Latin American work and her various photographs employing the mask. But this is no man, no human representative; this is a god's representative. But "which god?" might be the best question. Regardless of that, perhaps he is the representative of Wonder, our guide, our Virgil, to the new work and new worlds of Flor Garduño.

GREG GORMAN:

Anonymous Gods and Celebrated Men

BY EDMUND WHITE

The nature of the human body is to be frail, vulnerable, imperfect and to suggest its own decay and dissolution. As Roland Barthes points out, photography of the body and face is a foreglimpse of death: "The Photo is like a primitive theater, like a tableau vivant, the representation of the motionless and painted face beneath which we see the dead." The photographer's very insistence on the lifelike appearance of the pictured body, its vivid transparency, is an undertaker's and paradoxically implies the opposite: that this person, so present in the picture, is no longer like this, is no longer . . . alive, perhaps.

Greg Gorman defies this feeling by showing us bodies posed in impersonal, heraldic configurations, as if they were emblems rather than individuals, talismanic rather than particular. His men break the laws of gravity, their limbs inscribe strange, flamboyant designs against the black or gray or white seamless of the airless, unsituated studio. They assume an allegorical identity, like a double-headed eagle or gilt figures high above, measuring out the hours with their somber revolutions. These are men without imperfections (they don't even show the flaw of having a personality). There are no asymmetries, no moles, no disgraceful hanging flesh.

For instance, the back of one man is a descending hierarchy of broad shoulders, narrow hips, smaller calves and an exquisitely turned (and lifted) heel. This is a herald beating a huge bronze gong, we might say, or a brand new revised model of humanity

just unveiled by a perfectionist god. In another picture the man, on tiptoe, hugs his knees, as if to question the laws of locomotion, though the tenderly modeled striations in his hips and the long muscles of his femur attest to mechanical perfection. We feel that Gorman has not only posed these men but also created them; certainly the perfected techniques of studio photography have been matched by the state-of-the-art training of the young male body, and at no previous time in history could these flawless images have been registered in exactly this glossy way.

Yet another model is turned towards the light like a heliocentric organism, his knock-kneed pose a way of demonstrating, by implied contradiction, the ideal poise and heft of his body. He is like a ballerina who does a comic turn as a waddling duck so that a moment later she can all the more dramatically soar aloft as a swan.

Perhaps these men would die if they betrayed the slightest flaw. They are the opposite of the girl in Hawthorne's tale who perishes when her father attempts to remove her only defect, a birthmark. Unlike that heroine, these models are not subject to mortality because they have not even the smallest imperfection. They are more figure-heads on the prow of a ship than flesh and blood beings; often they are looking away, so that we don't have even the drama of an expression to interrupt our pure contemplation. These are men from a country where no one has a name, a history or a destiny. There is no past or future in this country. There is no will, no yearning: no

desire. Wallace Stevens was wrong when he wrote that death is the mother of beauty. These men will never die and yet they are certifiably beautiful. If they had been designed it would have been at the moment when the aerodynamic suavities of the art nouveau gave way to Brancusi's smooth boulders of abstract elegance. If they are placed against seamless, vaguely glowing backgrounds it is not to expose their humanity, to throw it into relief (as in an Avedon portrait) but rather to restore them to their airless, non-corrupting habitat: a cloudless, poreless membrane of graded light.

I am describing the Gorman photos he has chosen for these pages. In later work he has introduced the narrative of personality. Now his men and adolescents are no longer static Platonic ideals but rather the swirling shadows on the walls of the cave. Not that they're not handsome but now their beauty has a function (one man's hands are bandaged like a boxer's) or a troubled spirit (a subject frowns into the light and another appears offended by our impertinent gaze).

Sometimes in urban American slang a difficult person is said to have "a lot of attitude." These men strike nervous, unbalanced attitudes while evidencing plenty of aggressiveness or edginess, that more contemporary kind of "attitude." One young man, with a kid's frank regard and an adult's heavy-hung sex, looks at someone "offstage" with an amused expression that hasn't yet decided whether it's curiosity or seductiveness.

In these more recent photos the studio seamless gives way at times to chairs, candlesticks, rough-hewn wood plank walls—or the staring studio lights themselves. Or we are outdoors. We see a water-worn rowboat or overarching rocks or a working dock. The models are no longer anonymous and perfect but tattooed or embarrassed, dreaming or irritated; one of them is sprawling in a chair and looking right at us with

a daredevil cheekiness, though we can hardly take up the challenge since we're already mesmerized by the sunlight tracing the seam defining the ravishing edge of his full upper lip. One man, preposterously, kisses his own biceps in an ecstasy of narcissism that may be just a joke.

Gorman mixes photos of celebrities—usually young male movie stars—into these sequences. Of course we recognize Leo DiCaprio after a double take, but putting such a renowned face into a context of similarly beguiling if unknown presences serves as a reminder that celebrity could just as easily have descended on all these other candidates. If these stars are slightly diminished or at least "contextualized," the unknowns are promoted to potential celebrity. It is no accident that Gorman lives in Los Angeles; he is a serious, artistic update of the classic Hollywood photographer, the starmaker, or at least celebrity-recorder. Just as stars must live in mansions marked on a map, eat at a handful of recognizable restaurants and wear clothes from particular designers, in the same way they must have their photos taken by Gorman.

Perhaps his most challenging book is his most recent one, *Just Between Us*, in which he takes several hundred photos of one man, Greg Knudson. This is an individual with a full, complex visual personality, lovingly nuanced by Gorman. In this work the photographer has provided us with the very opposite of the photos shown here. These pictures are of types, not a fully explored person, whereas the Knudson pictures give us the lover's perverse and intimate portrait of a unique individual in all his moods and actions.

ARIANE LOPEZ-HUICI:
Monumental Beauty

"There is no excellent beauty that hath not some strangeness in the proportion."

FRANCIS BACON (1561–1626), *Of Beauty*

BY JOHN WOOD

Ariane Lopez-Huici's nudes are a primitive yet neo-classical celebration of the monumentality, beauty, and eroticism of the body. They sing out like a hymn of praise to the power, fecundity, and magnificence of the female. Her work goes directly to the elemental nature of *Woman*. Camille Paglia writing about the *Venus of Willendorf* said a number of things that could apply equally well to any of Lopez-Huici's grandiose women: "Her fat is a symbol of abundance. . . . She is the too-muchness of nature, which man longs to direct to his salvation. . . . Bulging, bulbous, bubbling. [B]ent over her own belly, [she] tends the pot of nature. . . . [T]rapped in her wavy, watery body, [s]he must listen and learn from something beyond and within her." [1]

We look at Lopez-Huici's images and we, too, learn from something beyond and within them. Lopez-Huici's women are not that primitive, ancient Venus—at least not all of her and not her alone. That eyeless, blind, and oblivious woman is Nature; Aviva and Lopez-Huici's other women are forces of Nature, women invested with the power of time's passage and the passing history of Western art and culture. Lopez-Huici transforms Venus into Vision, the too-muchness of nature into the very symbols of female power, eroticism, spirituality, and violation.

26

In the reclining portrait of Aviva looking at us, what might have begun as elemental and primitive Nature has become more well-defined, more expressive, more individual, and more erotic. Lopez-Huici has taken the raw material of Nature and transformed it. The *Venus of Willendorf* has become Titian's *Venus of Urbino*. Without actually alluding to other works of art but drawing on classic postures and poses of the human body, certain female icons of Western art are suggested by Lopez-Huici, icons that allow us to witness the transformation of the primitive again and again.[2] Old Venus turns new Venus. But with the passage of time and the coming of Manet, Titian's seductive Venus transforms into the far more sexually powerful and demanding *Olympia*, a figure closer to Lopez-Huici's *Aviva, 1996, #1*. And so, Lopez-Huici's image contains within it the simultaneous suggestion of three classic representations of woman: blind, omnipotent, and impassive Nature; pliant, passive, yet seductive sexuality; and finally the assertive, demanding eroticism of an equal partner in passion, the eroticism of a woman of the modern age. Lopez-Huici, however, catches up all three of these historical Venuses into one body, Aviva's, so that her one image resonates through time and cultural change to suggest whole histories of woman and how she has been perceived sexually and culturally.

In doing this Lopez-Huici forces us to wrestle with our notions of beauty. She creates images that are so clearly beautiful that we are enraptured by them even though their content might at first be jarring. We see large nude women, large nude men, a large nude mother and son, a crippled man who can do amazing, balletic things on his crutches. This is not the standard material of *beauty*, but seen through the eye and lens of Ariane Lopez-Huici, all bodies and all things all transformed. This act of transformation is one of art's unique functions—and its single *most* moral function—because it leads a viewer's eye to revelation, to new ways of seeing, and, thereby, suggests new and often more humane ways of thinking. Irving Penn showed us that the detritus of modern life—crushed cigarette butts, for example—can suggest the power and beauty of ancient dolmens, and in that act of suggestion, the past can serve as a critique of the present. Joel-Peter Witkin allows us to see, as mystics have for centuries, that death, darkness, and the *via negativa* can also lead to beauty; like Dante one sometimes has to traverse Hell in order to ascend to the Beatific Vision, and the path one takes can also serve as a critique and commentary on the times. And many other artists—Goya, Ensor, Bacon, etc.—have also made us confront our notions of beauty but few on so visceral a level as Lopez-Huici.

She confronts us with fat, assaults us with the immensities of flesh and forces us to look and look again. After we have finished seeing an exhibition of hers or studying a catalogue of her work or looking through a selection of her prints, we will have seen so much of the body's muchness laid out before us like sculpture that our prejudice begins to abate. And a serious prejudice it is.

Most every aspect of modern life as presented on television, in film, or in print is directed toward convincing us that fat is loathsome. Americans alone spend forty billion dollars a year on weight loss centers, health clubs, exercise videos and equip-

ment, diet meals, and drugs to suppress appetite.[3] At any time of the day or night several television channels will be running weight loss ads, exercise programs, ads for fitness machines, devices, or videos. And all the others will be presenting images that suggest that only thin people are beautiful, successful, desirable, sophisticated, healthy, or intelligent. Fat is assumed to be the antithesis of every positive attribute. We all buy into this myth, into the stereotype, and begin to think thoughts we never before had thought: Are my abs flat enough? Should I purge? Should I have my stomach stapled? Should I have my _____ reduced or enlarged?—with the blank being filled in by calves, thighs, nose, lips, breasts, and insanely on and on.

It is almost impossible to be a part of Western culture and not be prejudiced against fat. There is no ancient mystical tradition in praise of corpulence that Lopez-Huici can rely upon to support her images, as Witkin can his; there is nothing about fat that suggests, as Penn's cigarettes suggest, the ancient monuments and temples of the past—except for the *Venus of Willendorf* and similar figures—figures that go back into pre-history, that celebrate a time and a form we would not wish to know with any intimacy, a time when fat meant warmth and a better chance for survival, a time we associate with hides and the grease of animals and heavy thighs thrashing in flickering light at the cave's back.

Even though there is no ancient mystical tradition to sing the glories of body fat, prehistoric peoples, peoples who made figures like the *Venus*, had obviously figured out something modern science also knows but the Western ideal of beauty rejects: "extra body fat helps bring on menstruation and fertility and increases the chances of a healthy baby (heavier mothers produce heavier babies, who grow and develop faster).[4] And still to this day in certain west African countries, girls in preparation for mating are moved to "fattening rooms" in order to be plumped up before marriage.

Philosopher, poet, and critic Frederick Turner recently wrote, "Visionary realists are having to teach themselves how to . . . make mythic allegories that contain real portraits and landscapes that are appropriate to the human stories they contain, . . . how to imagine history in terms of landscapes and faces, how to put twenty-first century faces onto timeless neolithic bodies."[5] And that is exactly what Ariane Lopez-Huici does again and again and does like no other photographer. Joyce Tenneson and Jan Saudek both occasionally use large models but they are put to very different purposes than Lopez-Huici's. Tenneson's large women are all symbolic— they stand for other things. And Saudek's are fetishistic and often even comic or vaguely mocking. In neither case are they those artists' primary representation of woman and her beauty.

Both reclining images of Aviva look as if they could have been cut from marble; they, like the Willendorf *Venus*, have sculpture's monumentality about them. But Aviva from behind has the same delicacy of eroticism as does its sister image. She may partake of the most ancient of Venuses, but she is also Ingres' *Grande Odalisque*, cool and commanding. And if Aviva might seem too bulky or too big for our modern notions of beauty, one might note that she is no more too wide than Ingres' odalisque is too tall or too long. She is a Mannerist object, and like all Mannerist objects is larger or longer or taller than life. And therein lies our delight in such work. But in order to experience the delight we must be intellectually willing to embrace "the larger than life" and see it outside of our preconceptions and preju- dices. When we forget our prejudice against corpulence, Lopez-Huici's work sings out to us like any other hymn to the beauty of women—just as when we forget our preconceptions about the usual length of bodies, necks, legs, and babies Parmigianino's work sings out; as does Ingres' when we simply surrender to his obsession with the backs of women, an obsession so great that his distortion of the voluptuous back

of *La Grande Baigneuse* apparently went so far as to give her more bones than a back could house.

In Lopez-Huici's camera the transformation of bodies becomes an act of metaphor. Metaphor is the essence of poetry, a lightning leap of the imagination that allows us to see one thing in terms of something else, a *something else* often vastly different from what we at first saw. Metaphor makes creative connections we never before had noticed but which we instantly realize are both true and profound. Visionary artists, be they poets, painters, or photographers, construct their art, as Frederick Turner suggested, so that its most potent impact, its strongest current, is not conveyed through surface statement or surface image alone. Its charge is carried in what that statement or image connects with via the paths of myth, archetype, cultural history, and sensory and emotional similarities. Metaphors are not contrived similarities but connections grounded in sense experience and inherent in the mythic material of our collective unconscious; they are as one critic put it "the love forms have for one another . . . [because] they seduce the unity of things."[6]

Lopez-Huici's metaphors continually stagger us. She transforms Venus (*Aviva, 1997*) into St. Theresa in ecstasy and *Holly and Valeria, 1998* into one of Giambologne's monumental, neo-classical sculptures of the *Rape of the Sabines. Aviva, 1997* is clearly an image of orgasm and ecstasy, but she is alone except for the light piercing her as profoundly as the golden arrow of Bernini's angelic Christ-Cupid pierced St. Theresa. Like Bernini's Theresa who uttered "A bridal outcry from her open lips," Aviva has "lock[ed] the O of ecstasy within / The tempered consonants of discipline," as Richard Wilbur put it in a poem contrasting St. Theresa and Circe, the temptress who turned Odysseus's men into pigs.[7] Few things are more fundamental to the human history of the world than the relationship between women and men. The idea that an

enchantress, a temptress, a sacred witch, or whatever the Circe-like female might be called, can metamorphose men into grunting hogs suggests with little subtlety that men at base are pigs—or at least possess pig potential. Paglia writes, "Worldwide evidence is overwhelming that whenever social controls are weakened, as in war or mob rule, even civilized men behave in uncivilized ways, among which is the barbarity of rape" (p. 23).[8]

And so it would be an incomplete portrait of femininity if Lopez-Huici did not incorporate into her art images of violence against women. No one would doubt for an instant that the portrait of *Holly and Valeria* is a portrait of violence, but from where does such violence come and why does it exist? To quote from Paglia again, "Sex crimes are always male, never female because such crimes are conceptualizing assaults on the unreachable omnipotence of woman and nature. . . . The female body is the prototype of all sacred spaces from cave shrine to temple and church. . . . Everything sacred and inviolable provokes profanation and violation" (pp. 22–23). And this, too, Lopez-Huici presents but again with all the cool elegance of sculpture. With this image of violation Lopez-Huici has brought us full circle emotionally—back to thoughts of the *Venus of Willendorf*, back to the Mother and to Nature as our Mother.

The violation of the female body represents the violation of the sacred and serves to symbolize the violation of the Holy of Holies—the mother, the Mother Herself, the *Venus of Willendorf*, Nature and the very earth itself. When Nature is no longer alive to us and the earth is no longer seen as a living organism, when She is no longer recognized as our Mother, when all her garments of myth and metaphor are stripped away and She is nothing to us but minerals, animals, people, and plants to be plundered, pillaged, and polluted for cash, then she has been raped and defiled by her children. And we are back deep in the old cave's brutish dark.

Finally now we can see in the four photographs reproduced here a panoramic portrait of the female: the Mother or Nature Herself hovering over images of the goddess of love, the whore, the ecstatic but celibate saint, and the defiled Sabine. These are the great archetypes of women. They are the images of her glory, her pain, and the world's pain, as well. In thinking about what each of these images means and suggests to us, especially in its larger metaphorical, emotional, and philosophical contexts, we begin to understand the true monumentality and beauty of Ariane Lopez-Huici's art.

NOTES

1. Camille Paglia, *Sexual Personae: Art and Decadence from Nefertiti to Emily Dickinson* (New York: Vintage Books, 1991), pp. 55–57.

2. Arthur Danto has written a fine essay on Lopez-Huici entitled "'Soi' fait chair" / "The Enfleshment of the Self" in the catalogue *Ariane Lopez-Huici* (Paris: Galerie Frank, 1999), pp. 2–4, 21–22. After having met Lopez-Huici and seen her work and been enraptured by it, I immediately knew I wanted to write about it. She gave me a copy of the catalogue, but I made a point of not reading Danto's essay until I had completed my own. It was with both surprise and delight that I discovered I had made two of the same comparisons as he: Aviva as *Venus of Willendorf* and Aviva as *Olympia*. This suggests to me that what we both saw was no accident of our eyes but the very thing Lopez-Huici was shaping in her art.

3. Nancy Etcoff, *Survival of the Prettiest: The Science of Beauty* (New York: Anchor Books, 1999), p. 196.

4. Etcoff, p. 199.

5. Frederick Turner, "Visionary Realism," *American Arts Quarterly* XVII, #3–4 (Summer/Fall 2000), 12.

6. Calvin Bedient, "On. R. S. Thomas," in *Critical Quarterly* 14 (Autumn 1972), 259.

7. Richard Wilbur, "Teresa," in *New and Collected Poems* (San Diego: Harcourt Brace Jovanovich, 1988), p. 79.

8. As to the Homeric comparison of men to pigs, Paglia writing about the cries of sex said, "Most men merely grunt, at best. But woman's strange sexual cries come directly from the chthonian. She is a Maenad about to rend her victim" (p. 26).

Discourse on Desire

after the photographs of Wouter Deruytter

BY MORRI CREECH

By the very right of your senses you enjoy the world. —THOMAS TRAHERNE

I got no apologies for anything I done. —DONALD "PEE WEE" GASKINS

I felt before I thought: for even then I knew my body

was above all else a vessel of virtue, each sense

A means to my salvation—far more than reason,

Which often led to error and misfortune. All that my eye

Perceived, sleek rondure of flesh, the sun-streaked air

Of mountain altitudes, even the least grass blade

> I held the gaff to her throat. The stropped blade
>
> Told her I meant business, and there weren't nobody
>
> Near enough to hear her anyway. It was cold. The sea air
>
> Made her nipples stiffen under the t-shirt, and since
>
> All night on the road to Myrtle Beach I'd had an eye
>
> For tasting her sweets, I couldn't see much reason

Or stone in the street, was precious beyond reason.

It seemed as if all at once the seraph blade

That barred the estate of innocence was lowered, and I

Knew by intuition the ignorant joys of the body,

For even my ignorance was advantageous, every sense

Honed for those clear delights to which I was heir,

 To wait. I tightened a belt around her neck; the air

 Stopped in her throat, then came slow. She tried to reason

 With me at first, but pretty soon she got the sense

 Of things. I twitched her skirt off with my blade,

 Then run those cold inches against her bare body

 So she'd know what was coming next. By the look in her eye

And every taste insatiable. No pleasure of the eye

Nor appetite in its pure form ever led me to err,

But rather refined the soul to which my body

Was wholly wed—for is it not clear by reason

Of our very inclinations that the world is ours? No blade

Shall sunder man from his bliss if he follow sense.

 I'd say she knew. I made her do all that I liked. And since

 Nothing more was wanted, I looked her in the eye

 And told her she'd have to lick the blade

 Clean before I finished her. She whimpered to the air

 That she wouldn't tell. I cut her throat—didn't see no reason

 To let her live—and let the marsh crabs have her body.

The eye, of course, has its own reasons,

And may seek other joys to which the sense is heir

When body yields to the blade of appetite.

Nudes and Claws

BY JOHN WOOD

Pictures like these, even the frightening cock claws with their razor sharp gaffs, make us want to return to them again and again to be renewed by their beauty.

Though Wouter Deruytter's work can always be called beautiful, he is best described as a photographer of myth and mask. These are the subjects he returns to again and again to weave into his art. His well-known book *Knights of the Impossible* is an eccentric but brilliant mix of five mythic yet "impossible" orders of knighthood placed in jarring juxtaposition to one another, but it is also a collection of our public personae, those masks of who we are, presented in five suites that involve and intermingle the warpings of time, identity, and gender.

All of Deruytter's knights—be they cowboys, circus performers, men dressed as women, artists dressed in antiquated clothes, or Arab kings and princes—suggest a multiplicity of readings. They tell mythic tales; they suggest historical parallels; they force us to remember vanishing things we like to think of as permanent; they document changing ways of life; and they often exude a sensuality the sitters themselves may be unaware of. Deruytter's book *Cowboy Code* is a particularly brilliant example of this ability of his to tell a single story with many different plots.

What one will always find in any Deruytter photograph regardless of the subject is a finely chiseled, classical precision that produces artistic and emotional revelation through near documentary exactitude. His is a vision of clarity and brilliance that in

itself is emotionally affecting. We stare at his images and, as I said, return to stare again. And then we begin to understand the psychological levels Deruytter has constructed in them.

His sympathetic affinity with the world stems from the honesty of his vision, the fact that he can depict something's grandeur along with its eccentricity—the body's beauty alongside the often horrific products beautiful bodies can create, such as gaffs to increase savagery of the already savage act of cock fighting.

It takes a great photographer to make us see with new eyes, and to come to new, fresh, and deeper understandings. How many artists can put us in mind of that sweetest of the great English religious poets, Thomas Traherne, while simultaneously suggesting the foulest murderer? Few artists are capable of such revelation. Deruytter is because he also understands that "The eye, of course, has its own reasons, / And may seek other joys to which the sense is heir / When body yields to the blade of appetite."

Philip Trager's Dancers

BY JOHN STAUFFER

> *The Metamorphosis of nature shows itself in nothing more than*
> *this, that there is no word in our language that cannot become typi-*
> *cal to us of nature by giving it emphasis. The world is a Dancer; it*
> *is a Rosary; it is a Torrent; it is a Boat; a Mist; a Spider's Snare; it*
> *is what you will; and the metaphor will hold, & it will give the*
> *imagination keen pleasure. Swifter than light the World converts*
> *itself into that thing you name.*
>
> —RALPH WALDO EMERSON, Journal (August 1841)

> *O body swayed to music, O brightening glance,*
> *How can we know the dancer from the dance?*
>
> —WILLIAM BUTLER YEATS, "Among School Children" (1927)

Dance and photography may seem strange bedfellows. The one is a performative art based on body movement; the other is a still, two-dimensional representation. Yet many of the classic images in the history of photography suggest the movements of dance. They portray, if not dancers, people who have the athletic features and dramatic lines of dancers. Or they evoke in their composition the rhythmic motion of dance, even if they do not depict people. I am thinking of Southworth and Hawes' *Lola Montez* and *Lemuel Shaw*; Nadar's *Sarah Bernhardt*; Disderi's and Robert Demachy's ballerinas; Julia Margaret Cameron's *The Mountain Nymph Sweet Liberty* and *Ophelia*

series; Oscar Rejlander's *The Two Ways of Life*; Eadweard Muybridge's men and women in *Animal Locomotion*; Etienne Marey's multiple exposure portraits; Frederick Evans' *The Sea of Steps*; Gertrude Käsebier's *Evelyn Nesbit*; Alfred Stieglitz' series of Georgia O'Keeffe and Paul Strand's of his wife, Rebecca; Edward Steichen's *Greta Garbo, Isadora Duncan,* and *Charlie Chaplin*; Eugene Atget's street scenes of Paris; Edward Weston's vegetables, clouds, dunes, and nudes; Man Ray's solarized bodies; Barbara Morgan's and Imogen Cunningham's portraits of Martha Graham; VanDerZee's young dancers; Harry Callahan's series of his wife, Eleanor, and his multiple exposure trees; and the nudes of F. Holland Day, Bill Brandt, Todd Walker, and John Dugdale. In these images, it is as though the photographers have become choreographers. They pay particular attention to the lines of their "dancers" and their position within the frame (or stage); evoke movement—or its opposite, stillness—through various photographic techniques; and capture the "decisive moment" of the performance.

You might think of dance and photography as the arts of metamorphosis. They begin with a piece of life—the human body, a moment in time—and transform physical reality into enchantment. The mundane becomes mysterious, monotony appears magnificent, and the world seems filled with wonder. But in the process of transforming a piece of the world, neither dance nor photography abandon or wholly transcend the world; they never lose touch with their raw materials, and continually refer back to the life from which they originated. Although dance sets a

human body in motion, and photography freezes a subject in time, they retain the body and preserve the moment, and thus redirect the viewers' attention back to the world.

It is in this sense that dance and photography are "realist" arts. They are arts *of* the world more than they are *about* a world. As the philosopher Stanley Cavell put it, "a painting *is* a world," which finds its limits at its frame. Dance and photography are *of* the world; we always want to know what a photograph and dance are of. Whatever else they may evoke, they refer back to the world and the human body. In dance and photography, the spirit, wonder, and mystery of art remain within the world, since both arts depend so heavily upon the world. To put it another way, you might say that dance and photography represent spirits in the material world.

These spirits in the material world—or metamorphoses without transcendence— that give dance and photography their magical qualities depend upon the use of symbol. What is a dance of? What is a photograph of? The answer is always a human body, a moment in time. But dance and photography are of many other things as well. More than most arts, they are symbolic arts, and the symbols begin to reflect one another like mirrors, offering up a great range of connotations. "How can we know the dancer from the dance?" as Yeats phrased it. There is no way of separating them. "The world is a dancer," Emerson wrote; and he said much the same thing about a good photograph: "it is life to life." If the world is a dancer (or a photograph), then the dancer and the photograph are not only symbols of nature, but of much more besides. As symbols they "give the imagination keen pleasure," as Emerson noted. The symbolic aspect of dance and photography is perhaps one reason why these arts are so often aligned and sometimes interwoven with poetry; they rely, for effect and meaning, more on symbol and metaphor than narrative.

As arts of the world and symbolic arts, dance and photography also unite consciousness and place. The "keen pleasure" we feel about a dance, dancer, or photograph adds significance to the external world, linking our feelings to a sense of place. This association between personal emotions and place is a phenomenon common to all times and art forms, but it takes on particular power in dance, photography, and romantic art in general. Perhaps it is no wonder that dance and photography began to flourish in the nineteenth century, when artists revered nature and emphasized imagination and emotions over intellect and reason. Both photography and dance flourished again beginning in the early 1970s, as Roger Copeland has pointed out, gaining widespread acceptance as arts in their own right. It was the era of "earth art," and a time when many artists embraced the natural environment and sought to bridge the gap between experience and aesthetics, the world and the body, place and personal feelings.

Wordsworth's famous poem "Tintern Abbey" exemplifies the link between personal feelings and place. Wordsworth's setting acquires a profoundly spiritual, almost theological force. He represents Tintern Abbey "realistically," with great precision, but also saturates it with his personal feelings. "These beauteous forms" of Tintern Abbey, he writes

> Through a long absence, have not been to me
> As is a landscape to a blind man's eye:

They give to Wordsworth a "blessed mood"

> In which the burden of the mystery,
> In which the heavy and the weary weight
> Of all this unintelligible world,
> Is lightened: — that serene and blessed mood,

In which the affections gently lead us on,—

Until, the breath of this corporeal frame

And even the motion of our human blood

Almost suspended, we are laid asleep

In body, and become a living soul:

While with an eye made quiet by the power

Of harmony, and the deep power of joy,

We see into the life of things.

The poet's "corporeal frame" is "almost," but not quite, suspended; he becomes "a living soul." Like a dancer or photographer, he transforms the natural world without abandoning it. It is this metamorphosis without abandonment that infuses the poet's eye with harmony, serenity, and the ability to "see into the life of things."

Philip Trager exemplifies the link between intense personal feelings and place in his dance photographs. Unlike most other dance photographers, who shoot their subjects in studios, Trager *choreographs* his dancers, setting them outdoors, on the stage of nature, as it were, in natural light, amid trees, water, sky, and grass. He refuses to subordinate the dancer to the photograph, or the photographer to the dancer, and works with his dancers in an equal partnership. "Most dancers have been photographed a lot," Trager told me; "they are jaundiced about a 'photo-shoot.'" And so he tells them that he is not doing a "photo-shoot," but trying to create a new kind of dance, and encourages them to be creative and emotionally expressive. The powerful feelings that emerge from the collaboration are shared feelings between photographer and dancer. The effect is to give his dancers an inner life, while also transforming them into symbols that are rich with mystery and wonder. Like Wordsworth's Tintern Abbey, his dancers infuse the eye with supernatural powers. They become like living souls, or spirits in material bodies.

For Trager, eyes become a conduit to the soul. He seems to follow Emerson's maxim, from *Nature*, that we behold God and nature through the eyes. In his images of Mark Morris and Amanda Miller, their eyes are closed, as though they stand alone in nature, contemplating or absorbing its mystery. Their unseen eyes invite empathy between viewer, subject, and spirit world; they encourage us to contemplate the dancer's ethereal as well as material self, and the relationship between body and nature, body and soul, viewer and subject. Even when we can see their eyes, the effect is similar. Manuel Alum's eyes are open, but there is darkness all around and deep shadows veiling his eyes. A few rays of light hover above his head, halo-like, forming an aureole around his hood and producing the shadows in his eyes. His face, too, seems to radiate a thin stream of light as his head arches meditatively to the side; and his eyes seem to respond to another thin ray that flows up the right corner of the frame. John Kelly's eyes are also open, but he covers one eye and half of his face with his hand. He stares at us, an inscrutable, Janus-faced figure, as if uncertain whether clarity or obscurity will unlock the mystery of his world—and our access to him.

Trager's dancers have an ambiguous relation to nature, suggesting both communion and tension. Mark Morris looks like a sun-god; he opens his face to the sun, yet protects himself with his arm, which acts as both shield and preparation for *chaîné* turns. Manuel Alum's reflective body-suit protects him from the elements, yet his face absorbs and radiates the light of his universe. John Kelly, with his button-down shirt and knit tie, looks anything but earthy as he stands under the sky. And yet his boundless hair evokes the spirit of nature; it looks appropriate in this setting, and connects him to the energy of wind and sun. Amanda Miller has hair that no wind can ruffle. And yet she stands unadorned and unprotected (save for the evocative strap on her shoulder), in a meditative, almost serene, expression. All of these dancers have both feminine and masculine features. (Even Mark Morris, the most unambigu-

ously gendered figure, has soft, feminine lips and eyes, which offset his chest and arms.) They appear not so much as men or women, but androgynous earth children, performing a conflicted *pas de deux* with nature.

Dance began in nature. Its early settings were under the stars, around evening fires, and on the sunny hillsides of Greece. Yet throughout most of the twentieth century there has been an often antithetical relationship between dance and the natural world. Although modern dance emerged in part as a way to heal the split between the modern, technological world and the natural world, it is safe to say that most dancers—especially in ballet—"have found it hard to imagine themselves children of nature," as Joan Acocella has noted. Even today, very few dances are performed outside. Trager recovers the traditional relationship between art and the natural world. By connecting dance to its original setting, he reconnects his dancers to themselves, portraying their bodies while also betraying their feelings and souls.

Trager came to dance from architectural photography, and there is an architectural beauty to these bodies. By setting his dancers outdoors, and emphasizing the formal connections and tensions between body, light, and landscape, his dancers become "buildings of the body," as it were. He follows a long tradition in America of artists who blur distinctions between person and place. As the American Impressionist artist Childe Hassam put it: "The portrait of a city . . . is in a way like the portrait of a person—the difficulty is to catch not only the superficial resemblance but the inner self. . . . One should strive to portray the soul of the city with the same care as the soul of the sitter." This quest to personify and symbolize buildings and cities extends from John Winthrop's "City upon a Hill" and Whitman's Brooklyn to Stieglitz' and Steichen's Flatiron building; Hart Crane's *The Bridge*; Walker Evans' photographs of Brooklyn Bridge; and William Carlos Williams' *Patterson*. Trager

wants it both ways: whether photographing body or building, he seeks to capture his subjects' feelings and emotions—their inner life. In an extraordinary earlier work, *The Villas of Palladio* (Bulfinch Press, 1986, 1992), he gives sixteenth-century villas new life by photographing them in their natural settings. He juxtaposes columns and statues with shrubs and trees and links the curves in the land with the lines of the buildings. A similar fussiness with formal relationships is what gives inner life to his dancers: Amanda Miller's prominent jawbone parallels the shadows on her shoulder. John Kelly's tie runs along the same vertical plane as his exposed eye, and his collar and cuff buttons seem to speak to each other. It is this attention to formal relationships that creates metaphor and symbol, offering access to an inner life.

Trager's life has paralleled his art. You could say that it has been one of metamorphosis without transcendence. For most of his career he has been an artist living in the world, rather than trying to create a separate world of aesthetics. He grew up in Bridgeport, Connecticut, fell in love with photography at age thirteen, and has been photographing ever since. He had his first group show as an undergraduate at Wesleyan University in the mid-1950s, his first solo exhibition in 1970 at the Underground Gallery, and published his first book, *Echoes of Silence*, on architecture and the natural landscape, in 1972, followed by *Photographs of Architecture*, a study of Connecticut architecture, in 1977. He has since published six more books of photographs. He conceptualizes his projects as modern albums that he publishes as well as exhibits, much like poets who create unified books of poetry. What is most extraordinary about Trager is that throughout his prolific and influential career as a photographer, he has also had a successful second career as an attorney. He received his law degree from Columbia University in 1960, four years after graduating from Wesleyan, and ran a general-practice law firm while raising a family with his wife, Ina. While his passion has always been photography, law was a way for him to make a living and

raise a family. "I worked 40-50 hours a week as a lawyer, and 20-25 hours a week as a photographer," he noted. "It almost killed me." But photography revitalized his emotional and spiritual life. Finally, in 1993, he was at a point where he could quit law and devote full time to photography. "If you wanted to be a photographer, and you didn't have a trust fund," he says of his formative years, "you could teach, be a commercial photographer, or have another job that was totally unrelated." There is a wonderful parallel between Trager the artist who confronted his world as an attorney, and Trager the photographer who set his buildings and dancers in their natural environment— often in tense or conflicted ways—rather than in studios or in abstract space.

Despite the grueling work regimen, there were benefits to Trager's double life. During the 1960s and 1970s, when photography and prints were comparatively affordable, he acquired a breath-taking collection that now fills his home. Among his favorite images are portraits by Steichen, August Sander, Lee Miller, and Anna Duncan, and prints by Reginald Marsh, John Sloan, and Rockwell Kent. His collection itself charts his and Ina's intimate relationship with photography and prints, and serves as a source of inspiration for his own work. Working as an attorney also gave him a broad appreciation of creativity, regardless of field. "I learned to respect creativity in a wide variety of fields," Trager said, "rather than assume that creativity is the province of the artist. Not every artist is creative, and conversely some non-artists can be very creative." He recognized that creativity evolves in part out of a disciplined study of a field; and although he never formally studied photography, his knowledge of its history, practitioners, and debates is as astute as that of historians of photography.

Trager's study of photography became a source of nourishment and a way to connect with other photographers while working as an attorney. He began reading *Aperture* in the 1950s, and absorbed Edward Weston's *Daybooks*. "I looked to *Aperture* and the

Daybooks as sources of excitement, and validation of having an inner life suffused with photography," he noted. He also read most of John Szarkowski's writings, and after a professor from Wesleyan introduced Trager to him, Szarkowski acquired a print for the Museum of Modern Art. Trager is also conversant in postmodern theories and practices of photography, which have informed his commercial work for such magazines as *The New Yorker*. He learned to respect the time pressures of commercial photography, and the need to obtain good results quickly without sacrificing his vision and integrity. Because he was not economically dependent on commercial work, he only took on projects that struck the right chord with his aesthetic sensibility.

Trager's vision is based on his belief "that I can still produce emotions in people," as he put it, and the corresponding conviction that representing a building or a person in an original and moving way "hasn't all been done," as some postmodernists believe. His dancers are a testament to his ability to capture what he calls "the feelings and presence and emotions—the scene" of his subjects. What makes his work so unique, and gives it such emotional beauty, is his sense of the "scene" of his subjects—his painstaking efforts to capture the inner life of his subjects without abandoning their place in the world. In both his life and his art, then, Trager seeks to blur the boundaries between aestheticism and nature; art and work; building and body; body and soul; male and female. These dichotomies have long served as a source of order and meaning in art and aesthetics, leading many artists to choose between either lived experience or aesthetics, art or the world. Blurring these boundaries is Trager's way of creating beauty in an increasingly mundane world, and affirming a sense of freedom in a world of constraints. Perhaps it is no wonder that his work has focused on dance and architecture: he freezes time in the art of movement, and evokes in stationary objects a sense of time and movement. To both he gives new life and vision.

FLOR GARDUÑO

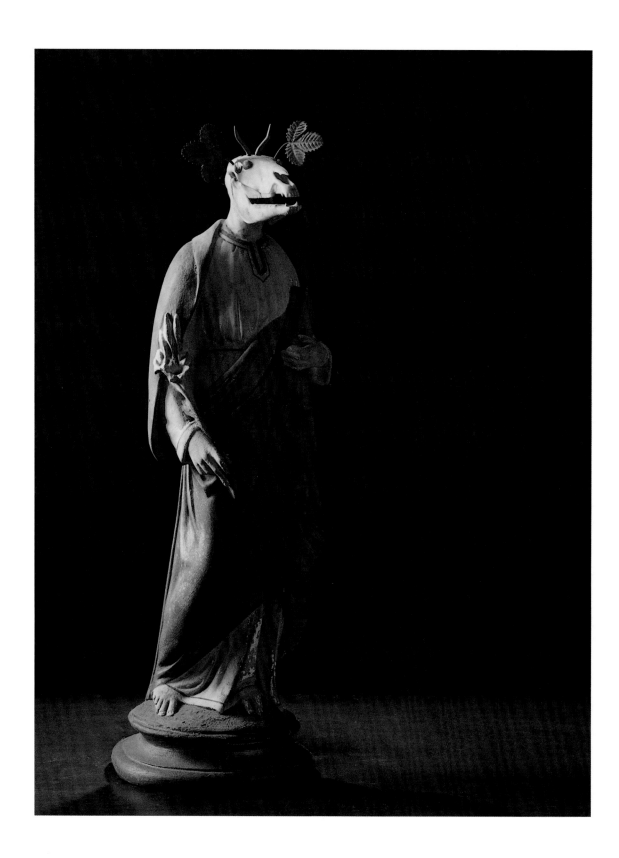

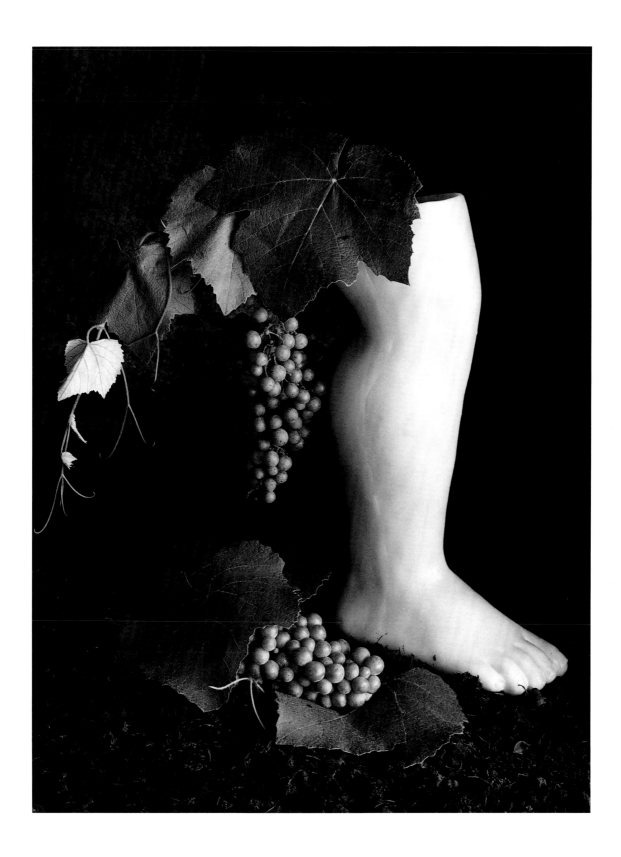

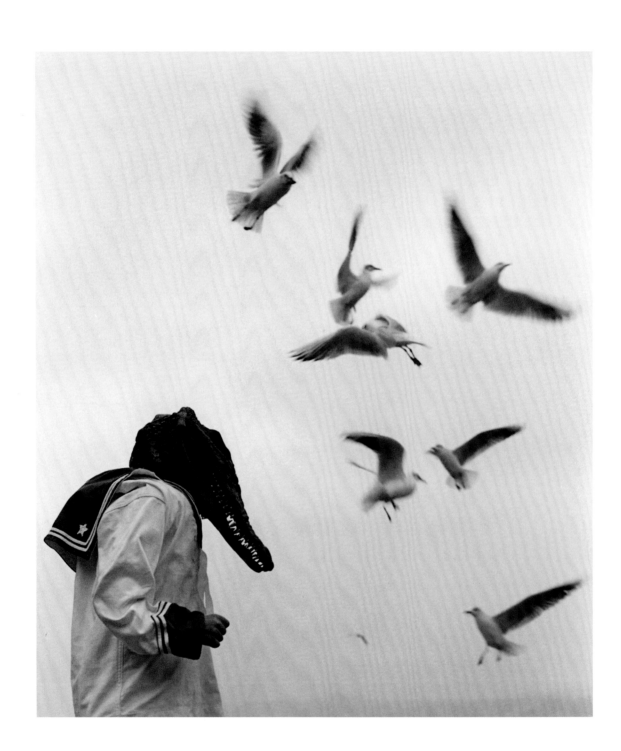

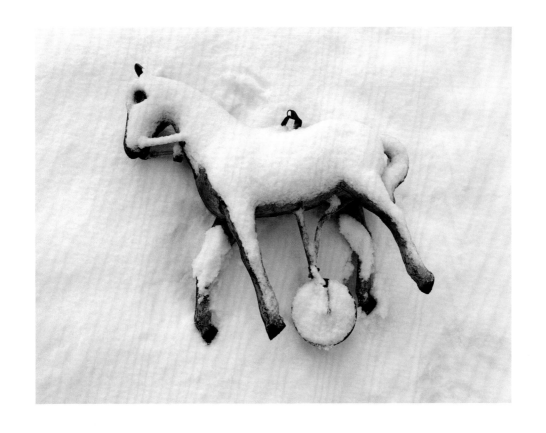

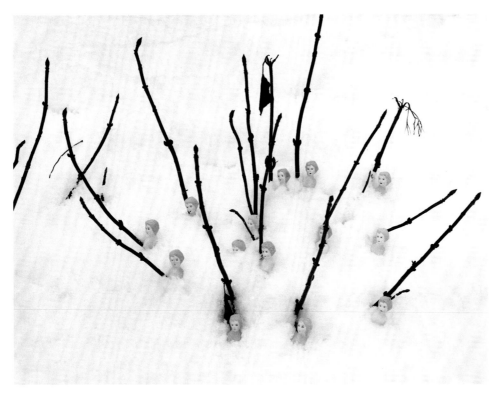

GREG GORMAN

Tony Bent Over

Tony Ward

David Michelak

Rex and Gregory

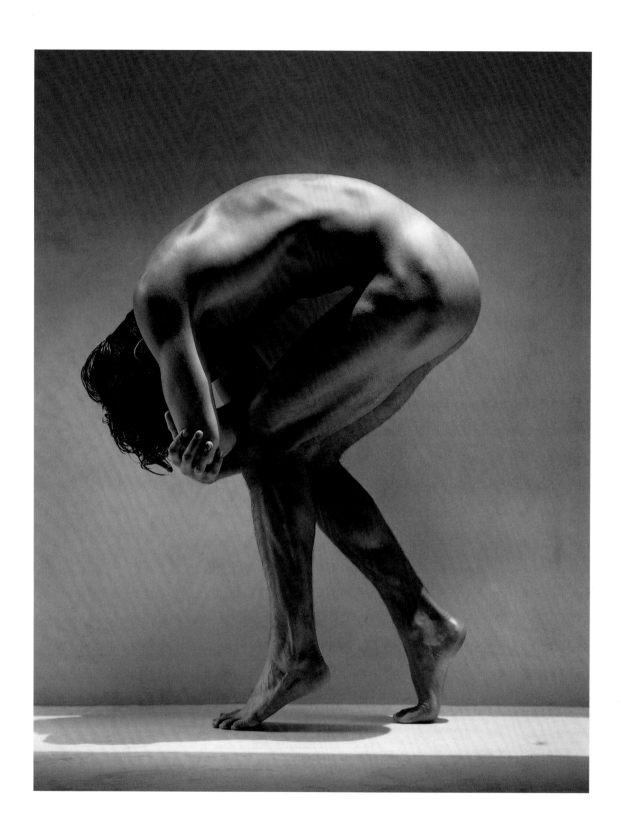

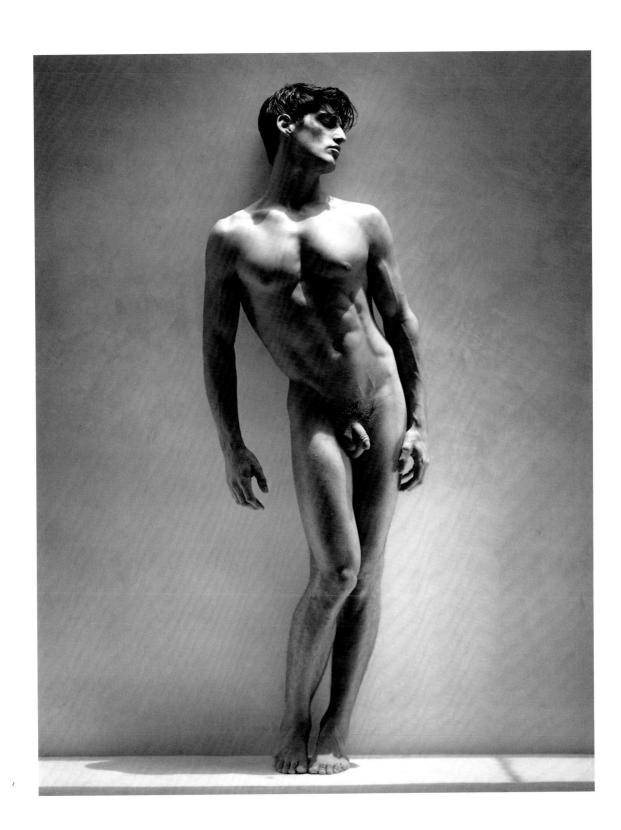

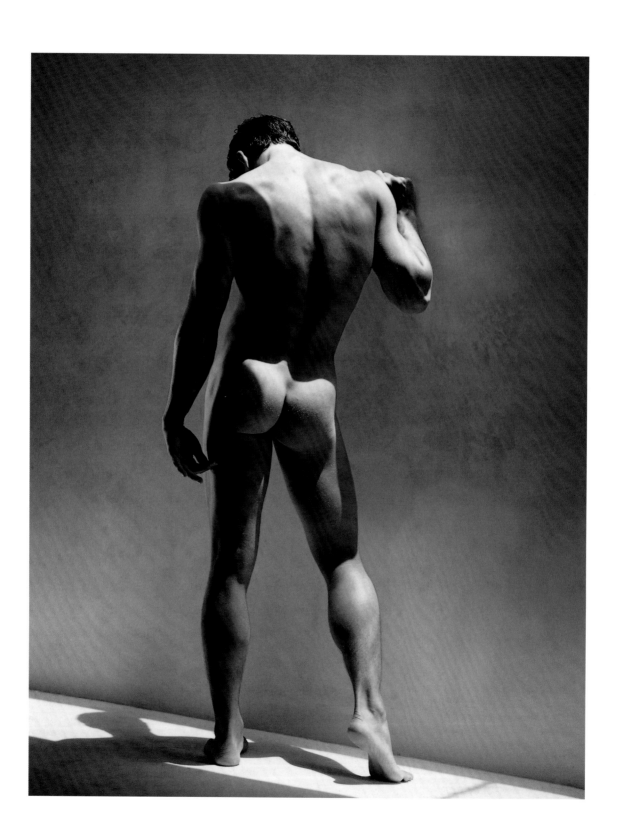

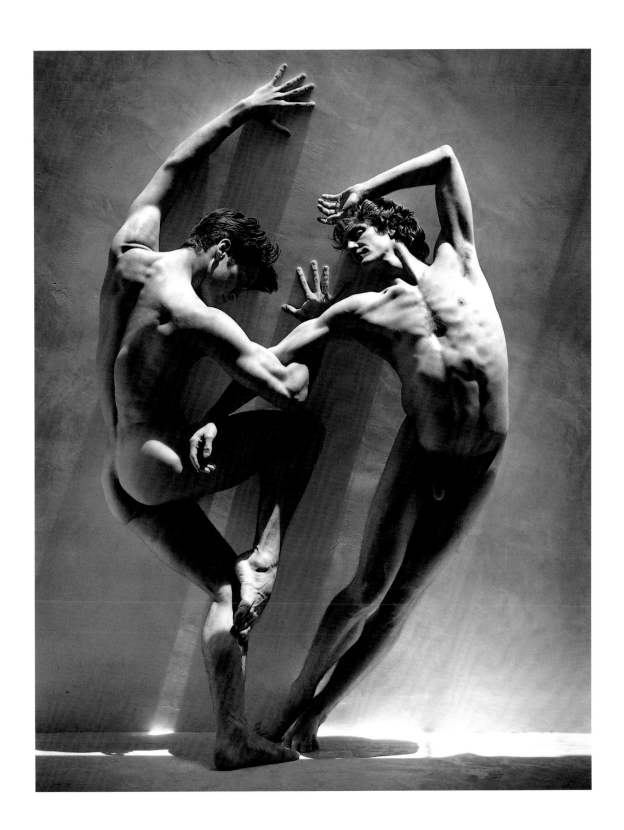

ARIANE LOPEZ-HUICI

Aviva, 1996

Aviva, 1996

Aviva, 1997

Holly and Valeria, 1998

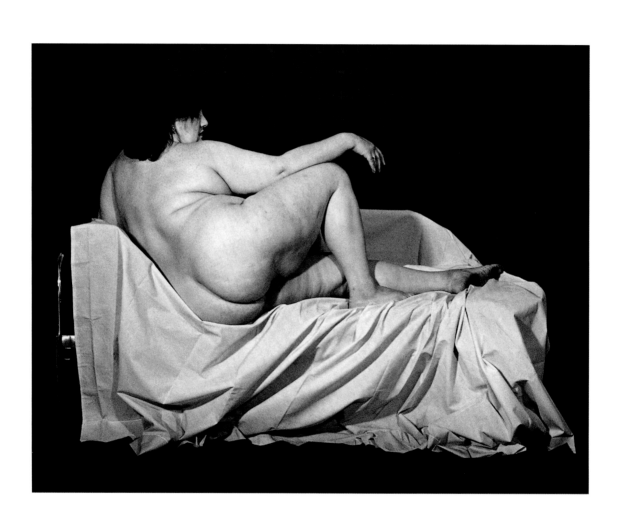

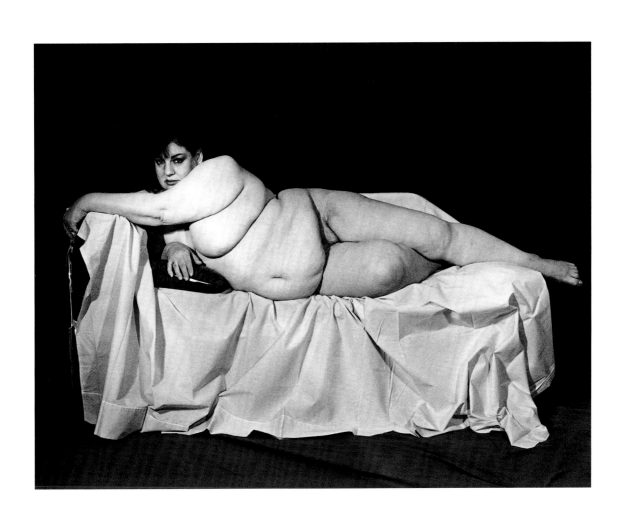

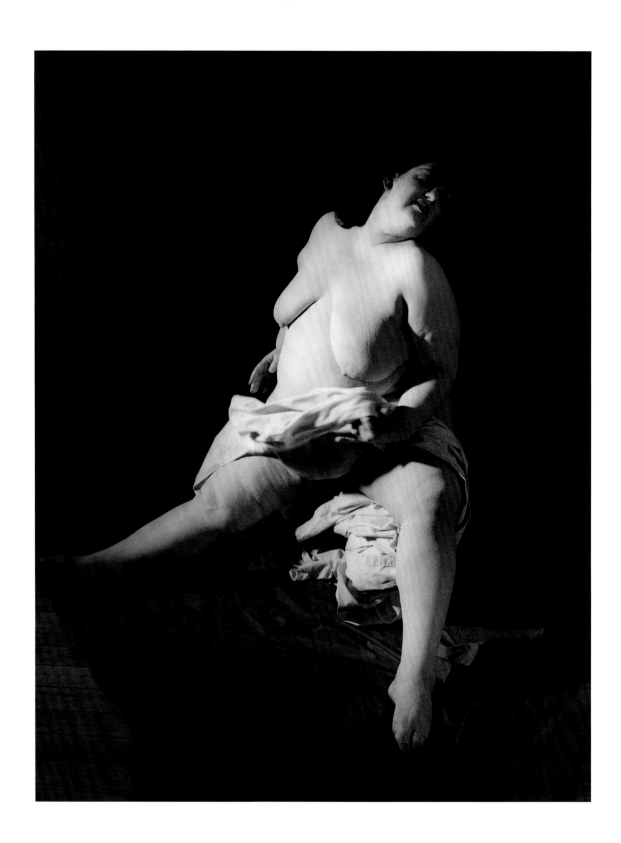

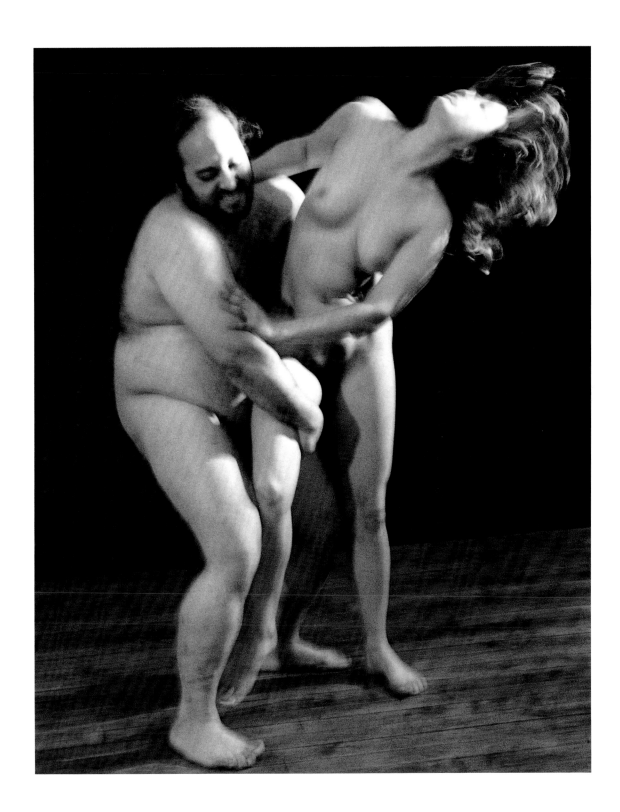

WOUTER DERUYTTER

Claw #2

Saskia

Claw #1

Willem

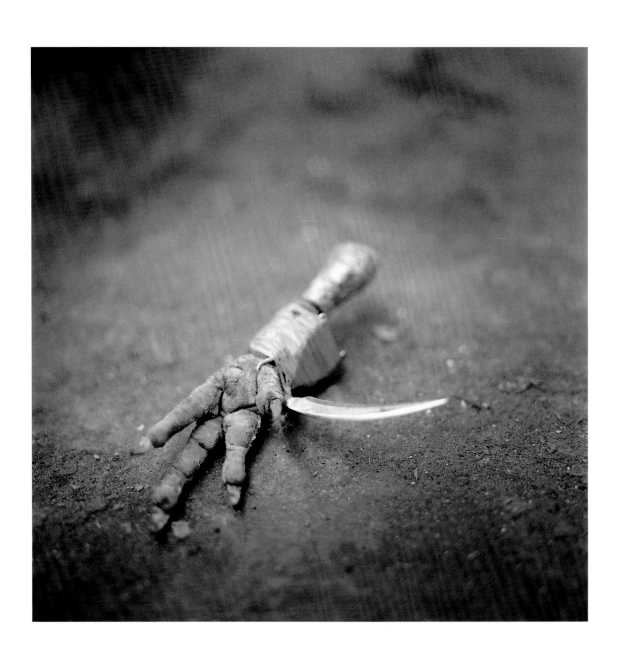

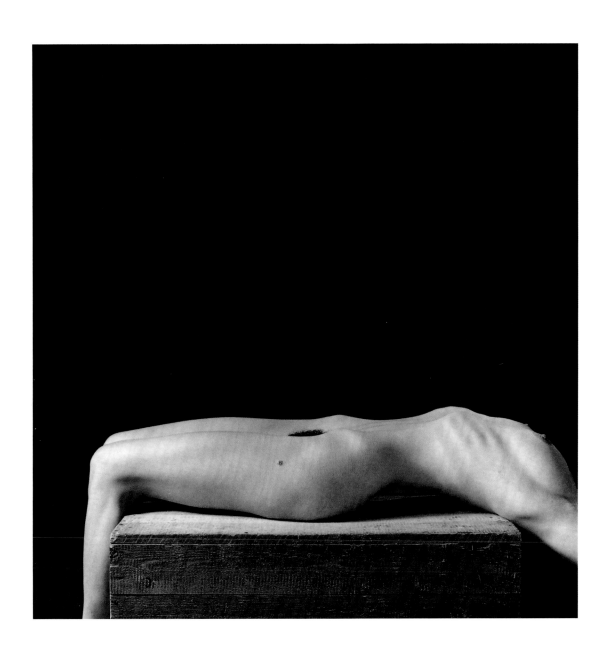

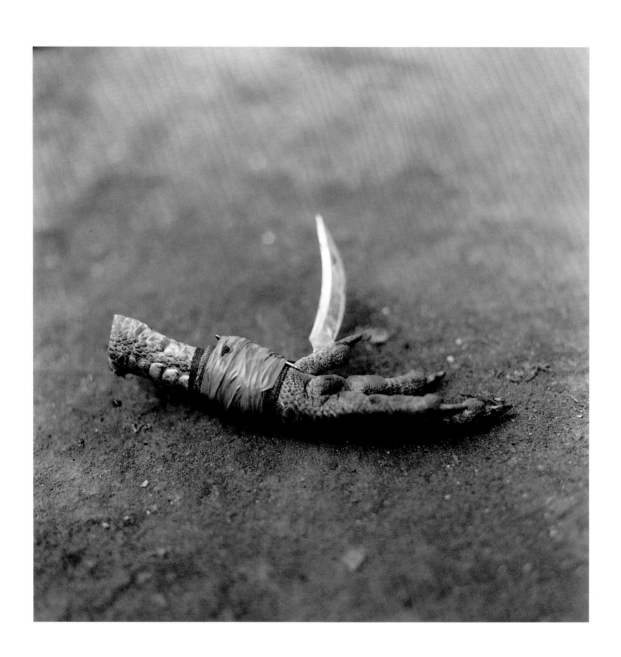

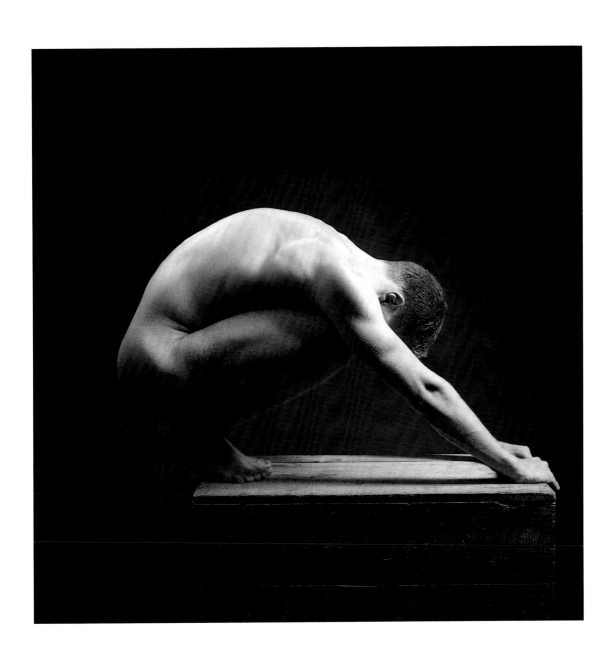

PHILIP TRAGER

Mark Morris

Amanda Miller

John J. Kelly

Manuel Alum

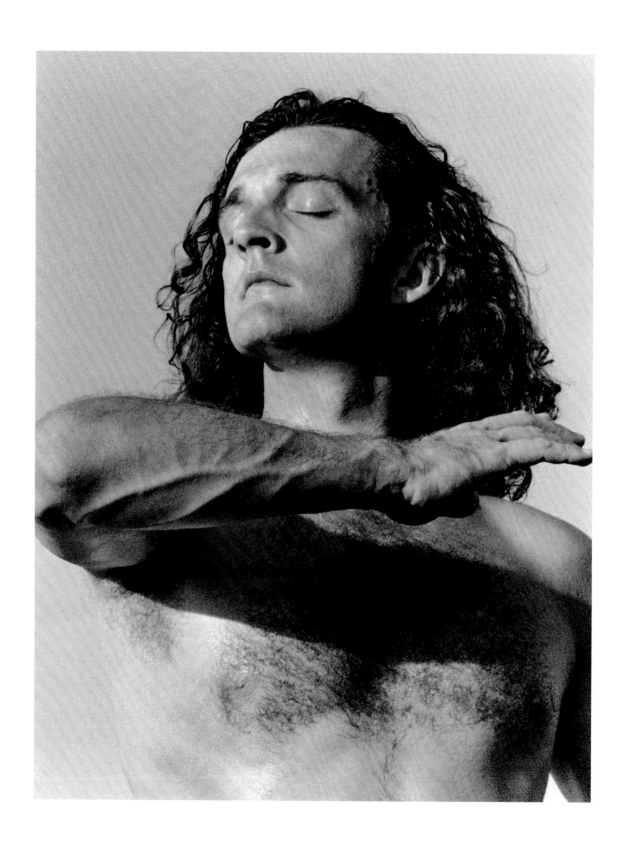

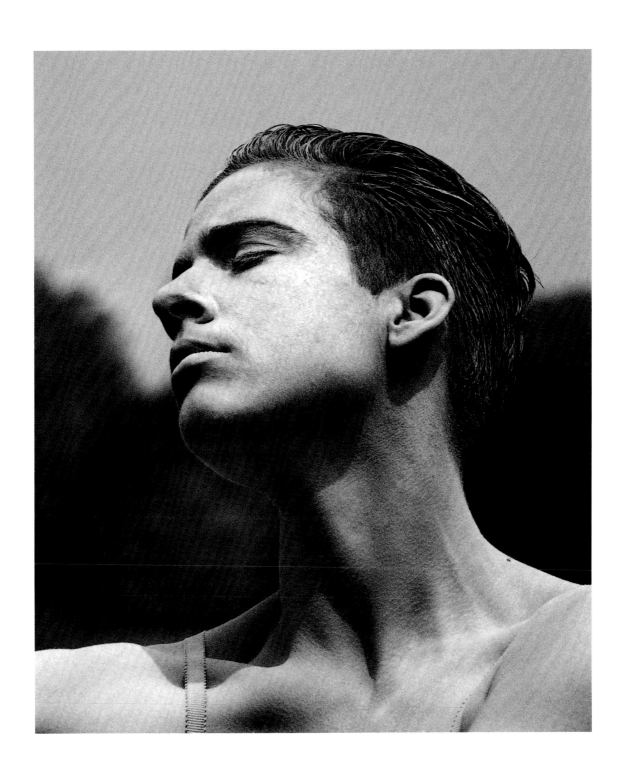

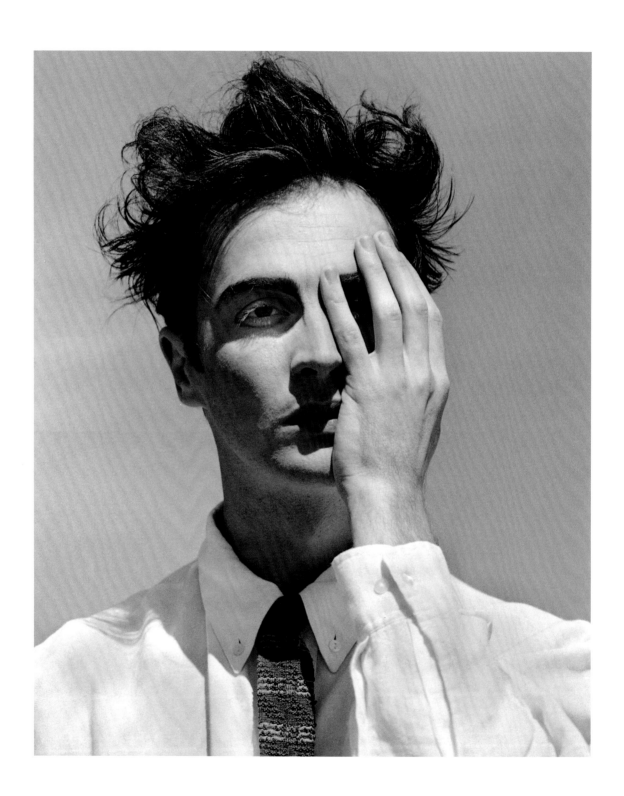

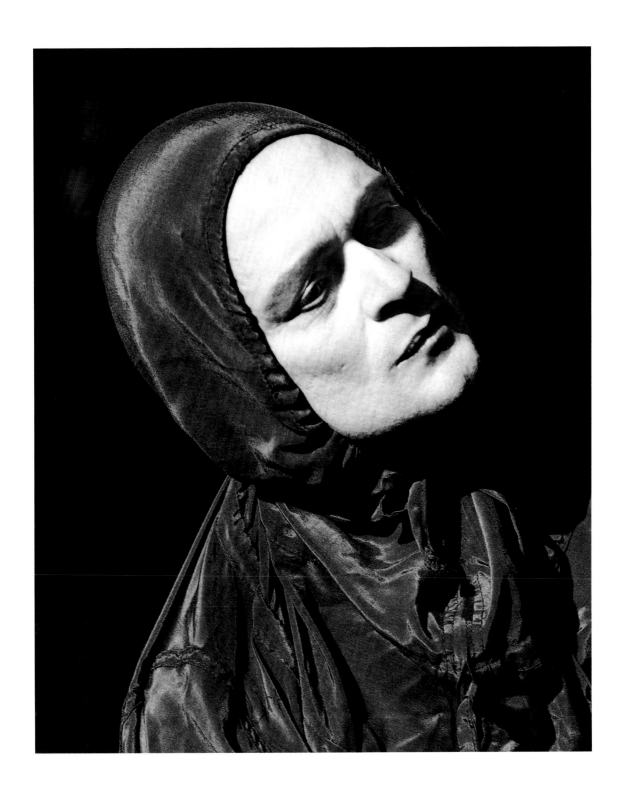

TO TRANSCEND OBJECTIVE ANONYMITIES:

The Photomicrographs of Jerry Spagnoli

BY LANCE SPEER

Before the rise of the antique mall, with its 200 to 500 dealers all under one roof, and before the advent of eBay, which brings such markets into my living room, there was the local antique shop. More often than not a "mom and pop" operation, such establishments ran the gamut. They ranged from small one room affairs to large old homes or store fronts converted into what, with little exaggeration, amounts to history's warehouse.

Such shops still exist, still proving the rule that one man's trash is another man's treasure. With a steady supply of "new" inventory coming from attics, basements and estate sales, it is not hard to see the niche these venues play in the recycling of the trash/treasures of yesteryear.

Ever since my undergraduate days as a journeyman photo historian, now more than 25 years ago, I have collected antique photographs. Back then I spent my time (and my money) almost exclusively at antique shops, as my slim budget precluded the higher priced images sold by specialized photographica dealers. While my specialty was stereographs, I also sought and still seek all sorts of related images and devices. Tintypes, *cartes-de-visite*, vernacular snapshots, magic lanterns and their slides, stereo-scopes and, with ever more difficulty in terms of simple availability, daguerreotypes.

Spending the day antiquing (alas, a verb these days) holds a variety of pleasures.

There is one twenty mile corridor near my in-laws' home in upstate New York that is peppered with no fewer than fifteen different shops, almost one per mile. Not only is a drive down the vineyard-lined roads of this area sympathetic to my need to get away, it also proves the adage that "getting there is half the fun." A day in the country reacquaints me with the neighborliness of small towns, often a cross between the 1950's homespun found as a backdrop to an O. Winston Link photograph and that of an *Andy Griffith Show* rerun on cable TV. Upon entering any one of dozens of such shops, I am greeted by the cheerful chime of a door-hung bell. Before me is a cornucopia of artifacts, debris from dozens of households, eras, family histories. I, like many seasoned collectors, am often able to take in the entire shop at a glance, immediately sensing where in the jumbled topography before me any photographs might be found. Sometimes when I spot a stack of stereographs or photographs from the door, perhaps piled in an old wicker basket (once with a small placard advertising antique *cartes-de-visite* as "Instant Relatives: 25¢"), I will head directly over to them to begin my search. Other times I will wander around, purposely avoiding my grail, savoring the palpable anticipation of possible treasure every pile of images potentially holds.

From among the sundry bric-a-brac neatly lining the shelves a grinning Alan Shepard stares up at me in glorious monochrome gray from the cover of an old Life *magazine, his exploits as the first American in space in 1962 fully documented between these covers. Admiral Dewey, hero of Manila Bay during the Spanish-American War of 1898, stares down at me from a rusticated picture frame hung on the wall. From beneath a thick patina of dust and dirt, General George Custer and his 7th Cavalry perpetually lose the Battle of Little Big Horn in an old lithograph above the Victrola in the back room. Old 1950's milk bottles*

from some long closed dairy; a flapper's beaded purse from the 1920's; a
rather shabby christening gown, now a distinct shade of yellow; a broken
Art Deco clock—all are artifacts of both distant and more recent pasts.
These disparate objects form a sort of cubist environment, going beyond
color, form and texture to include fractured facets of style, era and pur-
pose. Each artifact holds its own silent story, small tesserae in a mosaic
of cultures long since vanished, yet fondly remembered by those who
collect such relics.

Twenty-five years ago daguerreotypes were more plentiful in the open market of antique shops. As one of the first forms of photographic recording, daguerreotypes, with their requisite long exposure times, were initially more well-suited to still life, architecture and landscapes. Lenses and processes quickly evolved, however, to the point where the daguerreotype could fulfill its most democratic function— as a photographic medium for portraiture.

Most topographical daguerreotypes, as well as those of historical figures or events, have long since left the open market for the shelter of public and private collections. Portrait daguerreotypes, however, often remained with the family, to be handed down from generation to generation. With the inherent preciousness of their embossed gutta-percha or early Bakelite union cases, their velvet interiors, their elaborate brass mats, and the timeless sparkle of their reflective surfaces, it is easy to see why such images were often kept within the family circle.

It still amazes me to occasionally find complete family photo albums tossed out among the everyday detritus left by the curb for this week's trash pickup. Similarly, even some of the most sensitive and enduring portrait daguerreotypes I have ever

seen have ended up for sale in antique shops and now, of course, on eBay. With my small but decent collection of daguerreotypes, I know how this can happen. I own a sixth-plate daguerreotype I inherited from my grandmother. She once told me who the sitter was, and how this individual fit into our gene pool. Less interested than perhaps I should have been at the time, I forgot about it until I inherited this image after my grandmother's death a few years ago. Now I don't know, and can never know, anything about this motionless sitter, animated as he is by the beauty of the process. His anonymity assured, he joins the thousands of other nameless forefathers and -mothers that fill the boxes and drawers of my personal collection of tintypes, *cartes-de-visite* and snapshots. Were I not a collector, I, too, would probably have joined those who have since cashed in on such images.

Perhaps one of the most amazing and hypnotic aspects of the portrait daguerreotype is its hyper-real sense of presence. Individual sitters, usually dressed in their Sunday best, stare out at us with a remarkable immediacy. The highly reflective, polished silver surface of the daguerreotype holds only a ghost-like image of the sitter until the plate is held at precisely the right angle. When this perfect position is found, this precious object displays one of the most striking forms of visual recording. Desiccated ancestors seemingly return to life with a sculptural, almost three-dimensional presence. Gowns and drapery folds are as fluid and crisp as the day they were purchased. Eyes long dead glint anew, resurrected by life-giving light. Hair, jewelry, complexion are all rejuvenated, literally reflecting and reconstituting the original sunlight that existed more than a century ago that made these exquisite images possible.

Along with such perfect renderings, the portrait daguerreotype carries with it a supreme contradiction. While often considered one of the most sensitive and accurate forms of photographic rendering (notwithstanding the fact that the sitter and his or

her background are laterally reversed in the process), these perfectly delineated people remain perfectly anonymous.

Jerry Spagnoli is a master of the contemporary daguerreotype. Known for his exacting craftsmanship and intimate knowledge of the process, Spagnoli represents one of a current breed of photographers adapting antique processes to contemporary work. Others in this school include John Dugdale, working in cyanotype and now albumen; Jayne Hinds Bidaut and John Metoyer, both exploring the possibilities of collodion emulsions; and Christopher Bucklow, one of many employing the pinhole camera.

While not usually considered a "documentary" medium in the modern sense of the word, Spagnoli has created stunning documentary works in daguerreotype. Like George N. Barnard's *Burning Mills, Oswego, NY* (1853), Spagnoli has recorded a number of historic events, such as a half plate image of Times Square in New York City at exactly midnight at the turn of the millennium on January 1, 2000 (apologies to purists who know that the new millennium actually began on January 1, 2001). In his studio in New York on September 11, he ran up to the roof to create an amazing whole plate of the World Trade Center towers on fire.

Spagnoli's most recent daguerreotypes involve making full plates of isolated sections of human limbs and torsos. Rather than focusing on portraits or entire figures, with this work Spagnoli moves in closer to record hands, feet, legs, necks and various segments of torsos. A form of dispassionate scientific method is in play here, as these images are completely objective renderings of the human body, with the exactitude of the medium once again informing the work. Segregated from the whole, they are reminiscent of Renaissance figure studies, where painters and draftsmen

would isolate a particular part of the body such as an arm or a hand as a preparatory sketch for final oil paintings and engravings. Dürer and da Vinci come quickly to mind.

In Spagnoli's daguerreotype images from this series, the figures again carry with them a distinct sense of anonymity. They are astoundingly corporeal, and yet divorced from any whole, recognizable figure. These body topographies exhibit the characteristic minutiae of the individual model, yet remain unidentified, serving, as it were, to simultaneously represent everyone and no one. Scientifically and objectively exact in their reproduction, both antique daguerreian portraiture and Spagnoli's recent cartography of the human body reveal much in terms of detail, while forever dwelling in a world of anonymity.

Simultaneous with Spagnoli's exploration of the micro world in his highly focused daguerreotypes is his new and completely unique inquiry into the macro environment of the world around us. In Spagnoli's series of greatly enlarged photomicrographs, spectral figures act out strange choreographies that are both alien and completely familiar at the same time. Isolated figures dissolve and reconstruct themselves, as if viewed on a snowy TV screen. Everyday poses and gestures, quickly glimpsed, peripherally seen, alternate in the mind's eye between Michelangelo's monumental Sistine Chapel figures and typical, average scenes from the street.

Sandy, pitted, decayed figures perform some unknown gesture or ritual against an imposing blackness. Time (and acid rain) has battered and etched the once heroic figures from both the Parthenon Friezes *in* Athens *and the* Column of Trajan *in Rome to the point where detail and context have begun to disappear. In Spagnoli's* Cheering Figure

and Observer *we experience the same sort of dissolved context. Here an unposed, everyday gesture becomes some sort of Martha Graham choreography, a pirouette of lights and darks in some unknown space, sculpted yet made incorporeal by the same photographic process. What form of interaction takes place here? Celebratory, intimidating, offensive, defensive? Half seen, frozen in place, these shapes and forms are implied rather than described, simultaneously forming and dissipating in an exaggerated gesture of questionable origin and outcome.*

Spagnoli began working on this series of photomicrographs in 1997, concurrent with his daguerreian work. He seeks out macro environments, such as a major league baseball game at Candlestick Park in San Francisco. Working with a 35mm format Leica mounted with a 35mm or 50mm lens, Spagnoli chooses not to shoot significant players or any particular action on the field, as might be found in this week's *Sports Illustrated*. Rather, he waits for some important play to transpire down on the field, and then shoots across the stadium at the opposite side of the ball park to capture fan reactions in the stands. Of course at this distance, and by exposing relatively small 35mm film frames using a normal lens, his negatives do not have the stunning detail available in a 4 × 5 or 8 × 10 format. Instead, his images are characterized by a grainy suggestion of individual forms. Back in the studio Spagnoli places these 35mm negatives in a standard microscope, the kind commonly found in any college science lab, in this case specially fitted with a camera for taking photomicrographs.

With this tool Spagnoli slowly scans the negative for articulated figures that stand out from the crowd. The process both allows and forces Spagnoli to literally prospect for his figures, excavating them, as it were, from the surrounding raw silver gelatin of the negative. In this sense, the work stands as a supreme example of a photographer

relying less on the "decisive moment" than the "decisive edit." Not only must he scan his contact sheets for their possibilities, he must then scan individual quadrants of each negative for his final selections.

> *Like some far-off galaxy, formed of nebulous star clouds and deep pockets of dark matter, Spagnoli's* Torso *is both defined yet deconstructed by the photomicrograph process. This Herculean figure appears nude, which releases him from the constraints of any particular period, culture or personal identity. The distinction between background blackness and foreground form continually fuses and separates, finally congealing into a figure of both gossamer lightness and encumbering, age old granite. As if viewed through a sandstorm or swarm of locusts, this figure swirls in a space with no ground, no identifiable signposts— truly a place of physical and psychological pleasures and terrors.*

There is an element of the "automatic" nature of photography involved in this process. Spagnoli will travel to predetermined locations as diverse as a ball field, an urban street corner or a swimming hole in Hawaii, each of which might yield possible results, and then shoot macro scenes that look promising. On occasion he will place his trust in the camera and film's automatic ability to capture images he sometimes can not actually see in the viewfinder. It is only later, in the studio under the microscope, that he is able to sift through the raw material on the film to find the figures that best suit his vision. The result of this relatively convoluted process are his photomicrographs, blown up to life size and hung, frameless, on the gallery wall. Spagnoli uses the individual components of film technology, what he feels is "inherent in the film"—its random grain structure, its characteristic patterns of lights and darks—to simultaneously deconstruct and then reconstruct his figures.

Here the space between the subject and the photographer is mediated entirely by the medium itself—film as translating intermediary.

In creating these images, Spagnoli operates under very strict parameters, and he remains very deliberate in his methodology. He is interested in maintaining a rational, scientific method in his shooting, remaining as objective as possible when recording daily scenes, relying on no alteration of the original film or final photomicrograph. Likewise, preconception of the finished image is less of a factor with this work, as the final selection of what is printed is driven by what is eventually unearthed from the negative.

Defining the mere filament of a person, Spagnoli's Falling Figure *is in reality an individual caught in mid air jumping off a large rock into an inlet somewhere on the coast of one of the Hawaiian Islands. While this is what it "is," it is also one of the silhouettes, forever burned onto the sidewalk of the collective psyche, of a victim of the atomic bomb attacks on Hiroshima and Nagasaki. It is an 18th century plaster cast of a victim of Pompeii or Herculaneum, frozen in the repose of sudden death. It is a childhood memory, darkly seen, of the joys of the backyard trampoline. It is a god's eye view of the recumbent dreamer's reverie. It is what it is.*

Ultimately, these images are not about the specific individuals in the photomicrographs. All Spagnoli knows about them, other than where and when these images were captured, is what is on the film. This is exactly what interests him. His agenda, so to speak, involves the exploration of the ways objective visual cues can trigger opportunities for individual subjective interpretation. Here the viewer is challenged to bring his or her own self to the image. Just enough information exists in the work to make something out of these abstract patches of blacks and whites. What

that something is, its possible narrative or meaning, remains completely up to the viewer.

All this is not to say that Spagnoli's vision is left purely to chance. It is probably safe to say that everyone living now, or everyone who has ever lived, has at one point or another spent at least a small amount of time lying in the grass staring up at the clouds. Seeing castles or dragons or rabbits or horses is a common, probably universal, pastime. With cloud patterns, however, unless one counts the intervention of some unseen Higher Power, there is no external mediation or manipulation of these random arrangements. Spagnoli, on the other hand, does intervene through his editorial selection of images. Directed by the opportunities he comes across as he scrutinizes his negatives, Spagnoli reveals himself by what he chooses to print, what he wants us to see. His mediation stops there, however, as the objective forms on the wall present the viewer with myriad subjective opportunities to "fill in the blanks." Rather than becoming some formless Rorschach test, these images remain recognizable, yet possess rich opportunities for revealing the viewer's vision of the world.

The "Dance of Death" motif runs throughout the history of art, from Hans Holbein's masterful series (1583), through Alfred Kubin's Die Blatter Mit Dem Tod *(1918), to Ingmar Bergman's* Seventh Seal *(1957), to Fritz Eichenberg's wood engravings (1979–1980). A common thread uniting the work of these and the hundreds, if not thousands, of artists working with this theme is the actual depiction of the figure of Death. Two types prevail: the "active" Death, a figure who confronts or actually attacks his intended victim; and the "passive" Death, who stands off from the victim, suggesting the omnipresence of death or the foreshadowing of events soon to transpire. In some ways the "passive"*

figure is the more ominous. While perhaps not as immediately frighten-
ing as the attacking or menacing figure, the often casual pose of the
passive figure reminds us of the closeness, the everyday presence of death.
Spagnoli's Executive Figure *holds this power. Stepping out from the*
shadows is an isolated artifact of the everyday street. The random lights
and darks of hyper enlarged photographic grain that form this individ-
ual's head suggests a skull, facing right. The everyday "man on the
street" motif brings the figure that much closer to us, as if we too will
encounter just such a specter in passing on any given day.

With this work we are presented with an opportunity to understand the under-
currents of objective visual structure, and how it serves to inspire subjective, individual
response. In these images the evidence of an individual is recorded as raw, dispassion-
ate and disinterested data in the proscribed lights and darks of photographic emulsion.
From this (literally) spotty evidence, the viewer reconstructs these figures, and by
doing so brings with him his own subjective interpretations.

In this sense, these images of ambiguous visual structure challenge our relationship to the
visible world. The world in these photographs, like all worlds (including the ones we
each inhabit), is a fabrication, a construction with each of us "filling in the blanks" from
uniquely different points of view. At the same time these images challenge the way pho-
tography has traditionally been accepted and viewed: that is, as a high focus mechanism
for capturing and communicating the details of the visible world. One need look only
as far as Spagnoli's extremely focused and well crafted daguerreotypes to see this point.

The static pointillistic textures, the colorless palette of grain structure and
light create a scene reminiscent of some half remembered film still or

video outtake. The arrested walk of the Strolling Figure, *on a path to nowhere, is a common enough event that it borders on the mundane. Perhaps more highly delineated than most other pieces in the series, this image nevertheless remains disturbingly enigmatic. The comfortable sunshine that seems to permeate the scene does little to illuminate the unanswerable questions posed here. From where, to where does this individual travel? The same thoughts surround the secondary figure on the right, moving in robotic syncopation with the foreground man. What histories do these individuals carry? Are we them or are they us?*

Just as the anatomical detail in Spagnoli's daguerreotypes is out of context with the rest of the body, his photomicrographs are out of context with any particular time, place or culture. The extreme objectivity of the fleeting moments caught on Spagnoli's film opens the door to a host of possible readings. Here partial evidence serves as a catalyst, allowing each of us as viewers to make a host of valid subjective interpretations. Identifying meaning and context, then, is less a function of the photographer imposing his will than it is a much more open opportunity to transcend objective anonymity.

THOSE WHO HAVE ADDRESSED GODS:

Carol Munder's Voiceless Tales

BY ANNIE DILLARD

"I look for the figure," Carol Munder says. "I look for images to represent mankind."

Here they most existentially are: two assemblages of small Etruscan bronzes, one other not Etruscan, and two big, damaged male and female Greeks.

THE GREEKS

The feet of Dionysos have come a long way. They are paralyzed nubs of the human journey. What a pity the journey counts so much more than the humans. The photograph is a tour de force of middle tones.

The bashed woman whose fingers curve is what you might call a knockout, with or without her story. The life-sized hollow bronze sculpture depicts Julia Manaeo, an upper-class woman of Alexandria. The sculptor is unknown. After Julia Manaeo died, a ruler, for reasons now lost, declared her "damned in death." Someone obligingly smashed the sculpture's face. Those elegant fingers could not fend off the blow. The sculpture's beauty remains, and perhaps deepens, alongside her disfigurement. Neither rage nor damnation disrupts her calm.

DISPLACED PERSONS

Munder's compositions' might and boldly ambiguous positionings, their locked solidarity or their fiercely poised asymmetries are, with their controlled range of tone,

the stuff of photography, and themselves deserve a volume. Yet Munder surprisingly encourages our naively reading the subject matter.

"They are displaced persons," she says—of not only the sculptures but also of the humans or demigods they depict. Time and space have stilled and gagged them. They have fates not only as sculptures but also as the people they portray—like a novel's characters within the novel. This anthropomorphizing, this storytelling, which might seem to quit the print and scant the art, is nevertheless part of her own approach. Here is the human condition.

The prints give away little: we must enter them and interpret. Surely, the crouching and imprisoned mystery man beseeches. Does he want to warn us? To join us for Brie? Are we as he is? These figures cannot say. We cannot hear through their bronze, through their burial, through centuries and millennia, through the tremendous silence of a lost culture whose disappeared people could read and write but preferred not to.

SMALL BRONZES

All that we do, they witness. The statuettes—that is the technical term—hover between time and eternity. Motion and stasis gaze in equipoise. The figures reconcile these opposites by embodying them. Simultaneously they disperse and irradiate all by the blurred silence of their banishment.

Shorn of their own gods and people, they assemble to stand enclosed, each an isolate ontological puzzle. Those just-barely-there human forms, the bronzes whose edges dissolve, seem only half-born.

Sculpture's source is the human body; the body's source is lost in archaic awe and mystery. The figures' stylized gestures, solemn or ecstatic, haunt. Why does the last man in an evolutionary-like sequence, solid as he is, lack a reflection? Exuberant women hold the corners of their skirts. Their gaudy world has gone. Their voiceless tales replace some gods'. Some were decorative, some devotional. Some were pot handles, some grave gods. We know that many were devotees praying each to a god of whom we know nothing.

No one can read any Etruscan but a few proper names. It belongs to no known language group. No one knows what Etruscan religion was; it seems funerary, like the Egyptians'. The Etruscans, as if in a time-lapse film, appeared in Tuscany out of nowhere twenty-nine centuries ago. They grew rich; they sold to Greeks gold shoes such as Pallas Athene wore. They spread their civilization clear to Spain, lost their empire town by town, and completely vanished, all in four centuries. (Surely we will, by contrast, last, splendidly as we are doing.) They left behind some art and the gold women's shoes they sold to Greeks.

Only the beauty of the body remains of those who have addressed gods. Like all motionless things under the sky, they appear to wait out their days. Photography is intrinsically about time, as you cannot see the present on any print, but only some shred of the past. Photographing very old, physically unchanged votaries throws a curve—the silence of eternity—into the picture.

The chief thing we know: Munder prints awaken them and still them at a blow. They are exiles from lands and times that no one remembers. Their translucent edges are as crucial as their dark torsos. More layers wrap them than a mummy: their mixed metals, their makers' hands, their peoples' prayers and pots, their own long

paralysis while time covered their world. Their as-it-were personal loss rendered
the votaries inchoate and blind as well as triply mute. Their present museum cases and
Munder's plastic lenses add more layers, as do her genius, her art's sophistication
and heart's warmth, and the film, chemicals, paper, frame's glass, and now book, and
now you.

None of these propositions would be true if Munder had not photographed the
figures. She finds their losses. What are people? Her art, like any great art, does not
attach meaning to the world's things; rather it teases it out. We could see none of
this until Carol Munder did.

PHOTOGRAPHER

Carol Munder, born in 1952, studied art; she left New Mexico for the Florida Keys
in 1978. She lives in a four-room house on five acres of what she calls "swamp" on
the Atlantic side of Sugarloaf Key. Hurricane Georges made a mess there. She cleaned
it up and native plants grew back. A six-foot diamondback rattler wandered through.
She ran her own crating business for eight years. Her earliest photographic prints from
decades ago show cement statues peopling Cuban immigrants' Key West yards. In
1986 Nexus press published her narrative sequence of photographs about the making
of a zombie: *Fierce Power Bad Fate*. She favors roasted green chili peppers from Hatch,
New Mexico. Summers, she and Key West steel sculptor John Martini try to cool
off and work on a tight budget in Burgundy, for which trips they ship ahead boxes of
real books, literature.

Her wide smile endears her. In the sharp crystal rays of her big eyes you fancy you
can trace her thoughts' speed. Her manner is alert and calm; she laughs easily. Her
paroles are so matter-of-fact, without any affectation, that in her presence you think,

"This is how people are meant to be." Her cropped dark hair reveals her head's delicate perfection. She is very slim and so strong that after swimming she boards a boat from the water by laying a hand on the transom and, apparently, levitating. She looks the same wet or dry.

THE GHOST AND THE MONOLITH:

Some Photographs of Robert Stivers

BY BRAD GOINS

Life is one long process of demystification. When we are very young children, each object has the potential to enthrall us. We become attached to the most trivial of things, and, trivial though they are, they evoke in us an entirely satisfying euphoria. But as the years pass, every object eventually becomes familiar. Even as an adolescent, the individual finds himself bored with objects; with the lauded landscape and land-mark; and with the great world that is said to hold so many wonders.

The full-grown adult turns his back on the observed world and decides to direct his search for the mysterious to creations about unusually curious people or phenomena. He seeks for the bizarre wherever he thinks he might find it: Dostoevsky novels; Nerval poems; the lurid details of Suetonius and Procopius; the phantasmagoria of the sagas and the *Mabinogion*. After each work has been assimilated, a few especially strange incidents are recalled now and then, but only for brief moments. The seeker is left thinking, "That was odd. So what?" Ultimately, the most bizarre bizarrity leaves no more trace than anything else, and the tedious old world trudges on in its deadly dull pace.

So, in one last effort to find real mystery, the seeker turns to the curious and remarkable adults themselves: the painter who fills the canvas with the most insightful work one has ever seen; the eccentric who evidences abundant wit and exotic knowledge; the stunning beauty with long, flowing black hair and olive skin. Here,

98

surely, there is mystery. But no, here there is only the potential for disillusionment. One gets to know the fascinating person, and after a while, one starts to hear the commonplaces, the bland observations, the clichés, the repeated stories. Soon enough, it becomes painfully clear that the idol has clay in more than its feet. Once the great person is found to be merely a person who is sometimes capable of great things, the most one can hope to do is establish a warm companionship; at worst, one is left with nothing more than the Preacher's sad observation that there is nothing new under the sun.

In his photographs, Robert Stivers reinvests the world with mystery. At the heart of this great project is a recurrent attempt to rediscover in the entity that most often promises mystery for an adult—the human being—a mystery that mere acquaintance cannot detect. Stivers recovers the lost mystery of the human being; he then extends this mystery through the world of objects and buildings and oceans and sky.

A JUSTIFICATION AND A WARNING

I am a writer who is not industrious and not inclined to overuse of the thesaurus. I say that as a way of warning the reader that she can expect to find in this essay excessive repetition of such terms as *dark, darkness, black, blackness, mystery, distortion.* Though it is a justification of my laziness to say it, I maintain that this annoying

repetition of terms is entirely appropriate for the work of a photographer who is intent on continually working and reworking the basic themes that consume him. In the very most simplistic terms, Stivers' work is about darkness and distortion; about features vanishing. While such a statement reveals little about the photography, it may serve as a cautionary note for those who do not appreciate undeniably obsessive work. There is such relentless uniformity of technique in Stivers that one thinks that at some point, it must become boring to look at these images. It does not. They are revealing mystery and we are starving for mystery. Stivers' obliteration of human features and distortion of the world at large constitute a peculiar private alchemy that rewards the sensitive viewer with a rediscovered sense of the awesome.

TWO KINDS OF BEAUTY; A NEW KIND OF BEAUTY

I have no idea how many kinds of human beauty there are; for the moment, I will try to describe two. First there is the most mundane and least promising: that of the model or rare acquaintance who possesses the beauty of absolutely symmetrical features, flawless skin and uniformly lustrous hair. This is the beauty of a pretty picture that tells us nothing about what lies behind the surface of the picture.

Then there is the beauty that can be found only after long acquaintance with a friend or lover. One gradually discovers in another's imperfect face a beauty that is far more satisfying than that of a Botticelli Venus, for it is a beauty that conveys a quality inside the person that one has come to treasure.

The process that leads one to the realization of this latter kind of beauty parallels the manner in which Stivers creates the beauty of his most powerful portraits. Stivers' beauty is one that draws out the model's interior mystery and uses it to mystify the exterior. By stripping away much of what is typically seen on a model's physical

surface in a photograph—and in particular, most of the facial expression—Stivers

separates the model from mundane habits, interests and concerns, and shows

what exists in the psychic depths. Several of Stivers' portraits demonstrate that if

enough mystery is revealed, a dark and forceful beauty is discovered.

In one of the most appealing of these portraits, *Bust of woman, R* (plate 45, *Listening to*

Cement),[1] the details of the features are entirely obfuscated; the face offers only the

vaguest indications of the nature of the woman's personality. Suddenly freed from the

limitations of the personality and the stifling social world that has created it, the

person has become a mystery again. Conventional notions about the beauty of facial

features are of limited use in the viewing of this image. The features of the model

are represented only by vague shapes. But the shapes do create beauty, for they are

pleasing both in their generous curvilinear forms and their obviously symmetrical

relation to each other. It is a new kind of beauty—and therefore a beauty that

pleases us not just by its novelty, but by its mystery as well.

Real mystery is always at least a little threatening; always holds the potential for

danger. We are attracted to mystery because we hope to find in it some extreme

experience that will provide relief from the sameness in which we are mired. But

when we recognize the possibility of extremity, we cannot help but remember

that some extreme experiences are unpleasant.

That is a complex way of introducing the reader to the difficult fact that in some

of Stivers' portraits, the mysterious appearance of the reinvented face makes one

extremely uneasy, and the awareness of beauty may disintegrate in the viewer's acute

sense of discomfort. In *Face* (plate 20, *Photographs*), the subject's face rises up out of

the darkness. While there is certainly beauty here, the beauty is in no way felicitous.

The cold expression, and the huge size and stark blackness of the features, are vaguely threatening, and can be read as denoting bittersweet sadness, or resentment or hostility towards the viewer. *BIF (female nude, P)* (plate 3, *Cement*) presents a nude model who appears to be covering her eyes with her fingers. The fingers are indistinguishable from each other; they merge in a flurry of contorted darkness. They seem to be pushing off the top of the head and revealing what is inside. If there is beauty, it is spectral, or even ghoulish. Does another figure so disturbing it is almost frightening— *Seated Woman* (plate 14, *Photographs*)—offer a hint of grim beauty? If so, the hint is only a hint. In this work, the viewer is daunted by the challenge of finding beauty in a face worn out with disappointment.

The holes in Stivers' faces contain something deeper than mere emptiness. They are rich voids; they make up a bountiful abyss. Of course, these facial holes must, to some degree, suggest both emptiness and the alienation that human emptiness implies. But in Stivers' work, the alienation exists in a context of cryptic mystery—a mystery that may indicate esoteric notions; or old sadness; or the thousand other things that make up a complex and thoughtful spirit. The inner turmoil that the subject of the portrait actually experiences in her day-to-day life may not differ from the inner turmoil felt by all of us who have lost the sense of mystery. Stivers locates or creates in the subject an inner turmoil that is different—that is rich, sad and strange. The person has been made into a mysterious entity again. The adult now has its own mystery. That mystery is a disillusioned one; it may be bitter, cerebral or obsessed as well. It is a mystery nonetheless, and is satisfying on that account.

THE GHOST
In this essay, I will, for purposes of elucidation or amusement, compare several of Stivers' photos to two symbols from popular culture: one, the most famous of Chicago

ghosts, Resurrection Mary, and, two, the monolith in the Stanley Kubrick film *2001: A Space Odyssey*.

Resurrection Mary is the ghost of a young woman who was struck by a car on her way home from a dance at the O'Henry Ballroom in the 1930s. She was buried in Resurrection Cemetery, and it is there that the ghost is wont to hail cabs, whose drivers undoubtedly take Mary's 1930s ball gown and hood for savvy retro clothing. Resurrection Mary asks to be driven here and there; one cabbie reported that she went dancing with him. He found her a good dancer, but one who was quiet and cold to the touch.

The problem with Resurrection Mary arises after the cabbie drops her back at the cemetery. As the departing driver looks in his rear view mirror, he sees in Mary's hood only a black oval with no sign of a face. Each cabbie describes the sight as one that inspires a singular terror. What is it about the black hole of a face that is so frightening?

Blackness in Stivers can be a repository for either mystery or threat, and perhaps for the realms where the two overlap. Blackness and darkness beyond the figure often appear threatening, and the exterior threat sometimes seems to have inhabited the radically altered face. Take the case of the *Wrapped Woman* (plate 12, *Photographs*)—a ghostly figure if ever there was one. Like Mary, she wears a hood, which, of course, both frames and calls attention to what is inside the hood. For the wrapped woman, the eyes and a nostril become intensely black holes that allow the greater darkness to eat right through the being. The perpetual human struggle against the outside has ended, and the person and the exterior have become one. This may explain something about why it is that Resurrection Mary's apparent lack of face seems frightening;

such lack suggests that the human has been vanquished by a malevolent force immensely more powerful than all the human being's resources.

The *Woman with Face Covered* (plate 7, *Cement*) resembles Resurrection Mary. But there are two key differences; first, the equivalent of Mary's hood—perhaps a scarf or an unusually long mane—obscures the region of the face to a great degree. Second, what one sees of what was once the face is a round, apparently unbroken surface of murky white. Though the face's surface is smooth, we can somehow tell that the shape we see is, indeed, a face. This blank, glowing face is, for this viewer anyway, interesting and almost inviting (echoing, as it does, a vaguely defined, but nevertheless strongly sumptuous and erotic breast). As this photo makes clear, what is frightening is not the loss of features *per se*, but the absence of evidence that the face exists.

IMAGINATION SPREADS MYSTERY THROUGH THE WORLD

By finding and portraying the human mystery, Stivers is able to present a challenge to the threatening darkness of the nonhuman world. In some of Stivers' most striking works, patterns of light paradoxically emanate from the heads with the dark holes; these patterns spread throughout the ground and give the world beyond the human a texture that comes not from the world's threat but from the creator's discovery of what is mysterious in the person, and of how this might be used to structure the world—to leave the pitch black world etched, however minimally, by human creation and inspiration.

A powerful example is *Self Portrait in Water #2* (plate 1, *Photographs*). Simply by bowing his head, Stivers has made himself into Resurrection Mary. (Stivers is not a Chicago cab driver; in his world, mystery can still thrive when the face has vanished.)

Surrounding the head is a slender aura that spreads out into the sea in a series of tiny wisps of light that create an eerie, otherworldly texture and—just barely—hold the water's immense darkness at bay. The quadrant immediately below the illuminated torso is a deep black, and remains poised in menacing opposition to the rest of the newly created world.

In *Woman on Knees* (plate 8, *Cement*), barely visible rays of light rise from the model's extended arms. The rays flow up from the figure to the top of the frame. Stivers is again embodying the world with the mystery of the human imagination—both the imagination of the photographer who creates the world and that of the vitally distorted model who houses the human mystery that so tantalizes the photographer.

In Stivers' work, the threat of the exterior world is always very real and the intrusion of this world can have a powerful, sometimes devastating, effect. Several images indicate that the great imaginative project is not always successful. For example, *Seated Man* (plate 4, *Photographs*) shows that an arm and even a leg can become mere slivers of light whose impact on the darkness is negligible. In *Baby #2* (plate 21, *Photographs*), the baby's face and chest are thin sheets of gray floating on the darkness; devoid of defenses, and helpless to imagine and create, the infant is hollowed out by gaping holes.

THE MONOLITH

It is one of the most powerful images in cinema: the dying explorer of *2001* reaching up to the monolith in one last silent supplication for an answer. The monolith is frightening yet irresistibly intriguing because, however intimidating it is, it seems to hold the key to the mystery; it seems to be the one thing that could—if it were inclined or able to do so—enable us to finally understand what our lives are about. Because we are creatures much given to fear, it is often the case that what attracts us

the most also frightens us. This is the situation that Kierkegaard, in a journal entry written in 1842, identified as dread: "Dread is an alien power which lays hold of an individual, and yet one cannot tear oneself away, nor has a will to do so; for one fears what one desires."[2] The monolith, and its equivalents in Stivers' work, are symbolic of this dread. The windows-made-monoliths of *Leaning Tower* (plate 16, *Cement*) and the rounded monolith of the arch in *Crypt* (plate 10, *Cement*) are inviting even though we sense that they may hide danger.

Bear (plate 40, *Photographs*) shows the imaginative creator finding obvious echoes of human features in the monolith; and in *Shadow of Man* (plate 5, *Cement*), the monolith is seen to have a human head, shoulders and even an arm. We finally see what we always wanted to see in the monolith: the evidence that there is something human in the ultimate revelation. When the mystery of the monolith is at last fathomed, we will discover that we are a part of it, and that discovery may be salvation for us.

THE OUTER DARKNESS

Whatever hints of ultimate salvation we may find in Stivers, he always reminds us that at present, we are still stuck in the world. For Stivers, darkness and distortion are the agents and creators of mystery. But, as we have seen, darkness can also signify forces in the outside world that may harm and that may be beyond our control. In almost every plate of *Photographs*, the outer darkness threatens to swallow up the image. *Two Seated Figures* (plate 24, *Photographs*) shows the heads of two models and the bulk of one model's torso disappearing into darkness. In *Ear* (plate 38, *Photographs*), only a single ear manages to escape the dark, and that ear is largely consumed by immense interior shadows that enable the blackness to cut right through the flesh. Stivers uses the various qualities of light and dark to restructure the world in such a

way that the human being gains some leverage in the struggle against dark threat and encounters a fundamental part of his being in the process. The world resists the effort; darkness fights with light; and the different kinds of darkness fight for dominance. We glimpse what is either an interplay or a contest between the dangerous darkness of the exterior world, and the mysterious darkness of the human and the light generated by its creative force.

In *Seascape* (plate 40, *Cement*), what at first seems to be a great dark bust looms up over the scene. The human mystery has become part of the forces of nature; indeed, the human seems to have a dominant presence on the coast. Though one can conjecture that the lighter areas are approaching or receding surf, one is not really sure what one is seeing. Nor is it possible to determine whether light or darkness has carried the day. In terms of its mass, the darkness has perhaps gained the edge; and even the light is not pristine, but is clouded throughout. Still, the most prominent part of the darkness takes a reassuring human shape.

The relation between light and dark in Stivers' world can seem to be that of either a complex interchange or a fundamental confusion; in each case, the relationship resonates with what an aware person will feel about the precarious balance between comfort and threat in the world.

WHERE DOES MYSTERY RESIDE?

This brief exposition of a few photographs is not meant to lead the reader to conclude that Stivers' works lend themselves to obvious, simple and comprehensive interpretations. Though the images are often inordinately dark, grossly distorted and riddled with disruptive holes, they will only seem bleak to the sort of people who want to have everything in life explained and neatly charted out. On the other hand,

the images will be reassuring to those who want to believe that mystery can still be found, or who wish that people could undertake some sort of endeavor that would make the world just a little less dangerous than it is.

I hope that I have managed to demonstrate that in some of his images, Stivers has breathed the mysterious back into the entire world, with the result that adults can experience the mystery almost as easily as children can. Does the mystery really reside in the person, or does the photographer choose to create this mystery and embody it in his photographic images of the person? I am inclined towards the former, but that is only a hunch. And it might not matter anyway. What matters is the sense that mystery really is there in the photographs. It is unfortunate that one must lose the mystery of childhood. But childhood and adulthood are different things. All one needs to survive as an adult is the hope that the mysterious will be encountered. Stivers' photos assure us that we have good reason to retain that hope.

NOTES

1. In this essay, I discuss works from two volumes of Stivers' photographs: *Listening to Cement* (Arena Editions, 2000) and *Photographs* (Arena Editions, 1997).

2 *The Journals of Kierkegaard*. Trans. Alexander Dru. Harper, New York, 1959, 79–80.

The Old Age of Georgi Dimitrov

after photographs by Jacko Vassilev

BY DANIEL WESTOVER

Today he moves slowly through beech and pine,

trudging in ankle-deep snow. His dog digs,

burrows in blue shadows on the hillside.

Far off, like a memory, smoke rises

from the slag and smelt of the Pernik mines,

painting the low clouds with coal-ash and pitch.

His boyhood often brought him here with skates,

to sprint the length of Kovachevtsi pond.

How large it seemed! Steel blades flashed in the sun.

Now wind scrapes the surface. Between his boots,

his shadow cracks; the ice will not hold him.

He leaves the pond, walks on, treads the treeline.

At the base of a warped beech, he pauses

in the well, pulls a glove off with his teeth,

and grips a thin branch like a walking staff.

In his mind, he scrapes away the ice glaze,

tears open the trunk, counts each frozen ring
to name the year when limbs began to twist.

The uprising, Leipzig, Stalin, Kostov
throw flames across his memory, then leave him
to falling flakes, and the raw touch of bark.

He lifts an arm to the wind and winces
as crystal shards click and scatter from boughs,
rattle the bones of every withered tree.

The Art of Don Hong-Oai

BY FANG JING PEI

Connoisseurship in Chinese art is as complex a subject as the understanding of
Chinese art in and of itself, the most complex of all, in my estimation, being that of
Chinese painting. To the Westerner much of Chinese art is defined by the limiting
but unsubstantiated words . . . beautiful, watercolor, repetitious, old master, Ming,
Song, etc. Not to fault the use of such terms and certainly not to fault the lack of
understanding of Chinese art by Westerners, it is only within the past half century that
Chinese art has been truly studied with attempts at understanding its meaning,
style and, yes, its connoisseurship. There are those who would argue that this is not
true and that Chinese art was collected and appreciated in the West since the eigh-
teenth Century; however, one need only look at the appreciation of Chinese paintings
during the past fifty years by the major museums to see the change in its appreciation,
both monetarily and substantive quality not to mention the highly influential auction
market. But even today, a master painting by a Western artist of, for example, the six-
teenth Century would command a much higher value than a master Ming artist of
the same period. There are those who would counter that Chinese paintings are unap-
preciated in the West because of "forgeries," copies and the fact that the now famous
deceased artist Zhang Daqian deliberately reproduced paintings signing the signatures
of the old masters only to foist them upon Western museums and collectors thereby,
in part, destroying the market for such works in the West. While there is some truth to
all these statements, an underlying truth also is present in the fact that Chinese paint-
ings remain misunderstood by many in the West. The similarities between Western and
Eastern art have roots which are distinctly different. These are but a few . . .

Artists who worked in landscape painting during the Song, Ming and Qing periods had little accessibility in terms of studying and modeling their works. There was no accessibility to museums for they were non-existent. Religious temples, Daoist and Buddhist, housed paintings but these paintings were distinctly figurative works. Hence, there was reliance upon collectors and the works produced by scholar painters. Collectors and scholar painters in turn were influenced by a particular master artist who usually had resided in their physical locale. Landscape artists relied heavily on imitating the styles of those artists which were revered, to whom they were exposed and to those who impressed them. In many instances, these were the same artists. Imitation therefore became something not to frown upon but rather a symbol of reverence and training; even the great artists came to imitate works of those artists who influenced them, literally down to every single brushstroke. And, the artist who could imitate the works of the master was seen as an artist of equal caliber. After mastering the works of their masters, it was then that an artist extended his individuality by placing his "fingerprint" upon the style of painting that had become so much a part of his makeup.

Another area of connoisseurship in Chinese painting is the study of the brushstrokes. No doubt connoisseurs in the West have heard countless times the fact that the highest form of Chinese art is calligraphy. It is in calligraphy that the "strength" of brushstrokes and degree of control is most notable and in Chinese painting, these strokes are but to a slightly lesser degree less revealing. It is often said that the soul of the calligrapher or painter is shown on the paper of the artist through the medium of the brush and ink. One need only be aware that when the ink is "stroked" onto the absorbent paper of the artist that stroke is a *fait accompli*, a distinct difference as Chinese painting does not allow for over painting or a change in line in comparison to the techniques of Western oil painting. Moreover, the strength in each stroke

reveals steadiness, control over the amount of ink transferred to the paper as well as intent which is less subjective.

When I first saw the photographs of Don Hong-Oai in the book *Photographic Memories: Images from China and Vietnam* I could not help but to compare his photographic works with classical Chinese paintings. There is no doubt that these photographic works represent fragmented memories of China's past in subject matter, mood, layout, and black and white depictions as ink on paper. But beyond the cloak of these fragmented memories of China's past and images that reflect Chinese paintings, there is so much more that his works bespeak. Without knowing anything of his past, one could clearly sense the emotional influences of his background as his choices in subject matter provide a Rorschach canvas of the artist. Reading from a summary written on him in this book, I learned Don Hong-Oai was born in 1929 in the heavily populated southern commercial center of China, Canton. This was a period of turmoil and change in China, only eighteen years after the fall of the Qing Dynasty. His parents died suddenly and he was taken by his mother's maid in waiting at age two, a fortunate happenstance for anyone orphaned in China no less at that period of time. In 1942 at the age of thirteen he apprenticed at a Chinese photo shop and learned the craft of photography, a craft as opposed to an art for photography as an art at that period of time was little known. But he was fortunate to be exposed to the photographs of the Taiwanese artist Long Chin-San and later traveled to Taiwan to study with him for a brief period. At age 17, he left the master's studio and began to teach only to later graduate from Vietnam National Art University where he also taught drawing. He established two photography shops in Saigon, moved to France in 1974 and came to the United States in 1979. He is quoted to have said "I came to photography by accident . . . and it has been a hard life. I will retire to China soon. Each trip I leave something else behind—a lens, a jacket,

China is waiting for my return." One senses that he, as so many Chinese who reside outside of China, find themselves feeling without home roots but also longing for the comforts of the West while in China . . . i.e., without a country in both instances, always longing for the memory of the imagined past.

As with every artist, there are those life factors which develop which provide his particular work with the "fingerprints" that distinguish his works. Through Don Hong-Oai's influential years, he developed in keeping with the manner as the Chinese literati painters of old. He took the old "form," an imitative work as the Chinese connoisseur would describe, and upon that form placed his own fingerprint. In his instance, the placement of his own fingerprint is done both literally and figuratively for his technique involves the use of one or more negatives, each as a brushstroke coming from the soul of the artist, which provides strength, texture and mood. In Don Hong-Oai's photographs, the medium is not the brush but rather the camera; the ink is not the medium but rather the silver gelatin solutions. Yet, the subject matter remains constant with the powerful symbolism of mountain landscapes and the juxtaposition of flowers with their own symbolic representation.

I find the works of Don Hong-Oai compelling. There are critics in the West who find Contemporary Chinese art lacking in individuality and imitative of Contemporary Western art. In Don Hong-Oai's case, his works are unique works of Chinese contemporary art utilizing the medium of photography, a medium relatively unutilized in Chinese contemporary art.

Severance: the mosques of Bani

BY ROBERT OLEN BUTLER

After careful study and due deliberation it is my opinion the head remains conscious for a minute and a half after decapitation.

—DR. DASSY DE LIGNIÈRES, 1883

In a heightened state of emotion, we speak at the rate of 160 words per minute.

—DR. EMILY REASONER, A SOURCEBOOK OF SPEECH, 1975

ISIOMA OWOLABI, BEHEADED BY FATWA, 2002

Mother I cannot see your face I walk beside you too young to veil but I yearn for your eyes, surely I can see my mother's eyes even in public, let the men turn their own eyes away for my sake, but behind us are the nine mosques that have risen from the earth and their veined walls are beneath our feet, the desiccated road, for father takes us east to a purer love of Allah, and his back is to me—no—he has turned round to me, in Nigeria, I am nearly a woman, the veil drops before my face, he whispers that I live now where the road has ended on the cliff's edge and if I lift this thing between me and the world I will lose my balance and fall to my death, so my mother will never see my eyes again in sunlight, and there is a great rushing about me now, she lies dead and veiled and I slip into the night and the moonlight falls upon my naked eyes, my hand in the hand of a man whose body is unveiled and his part rises like a mosque of Bani, and I speak to the world a gentle truth about the prophet and the dark swims upon me I hurtle back along the road to the mosques of my home where I know that heaven is simply a shaping of the earth.

JERRY SPAGNOLI

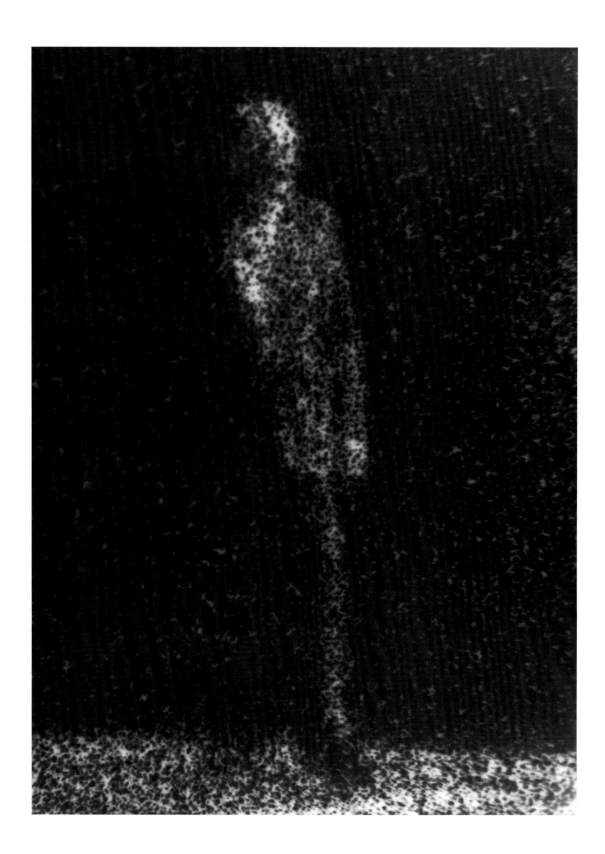

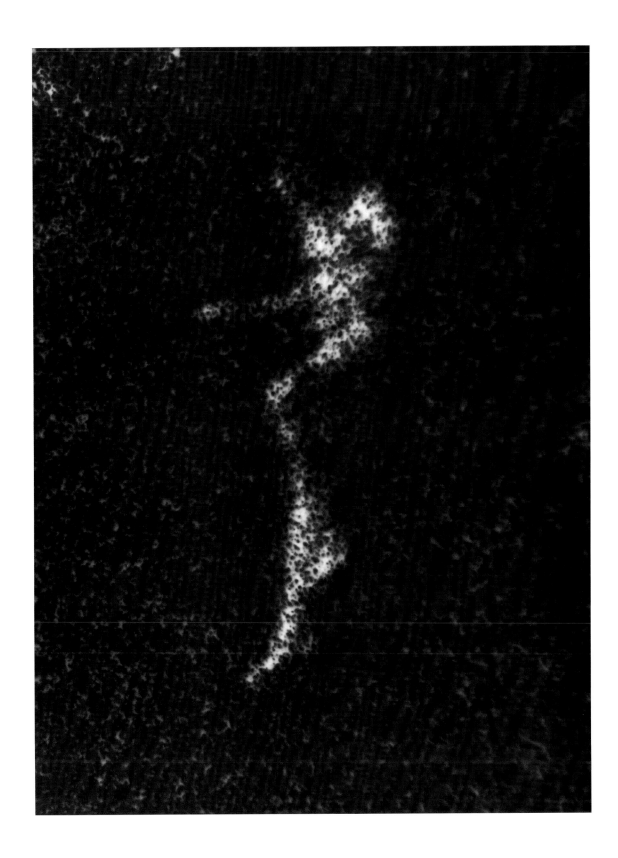

CAROL MUNDER

Small Bronze

Portrait of Julia Manaeo

Feet of Dionysos

Small Bronze

Small Bronze

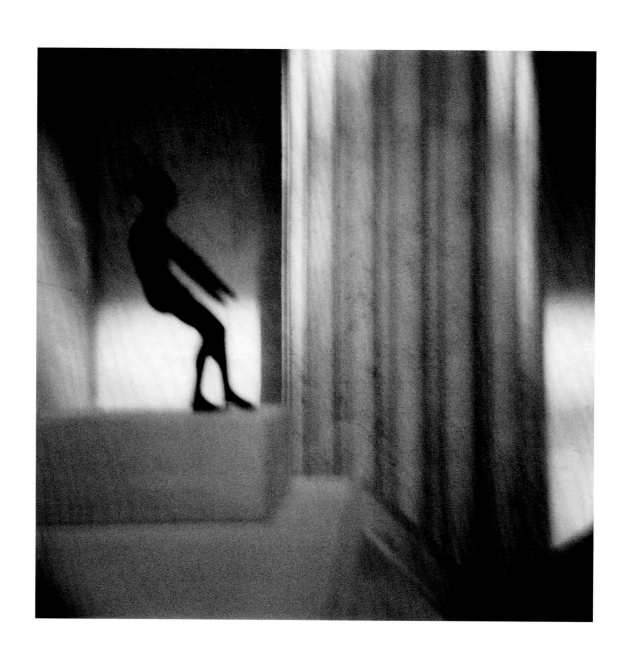

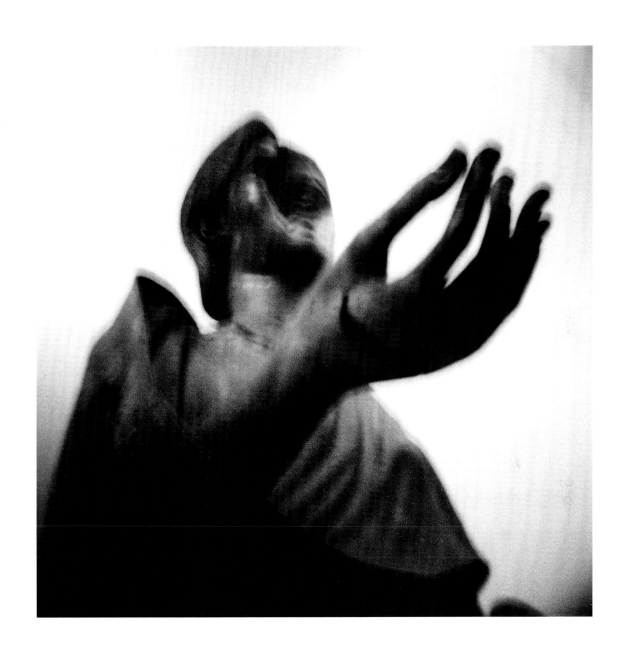

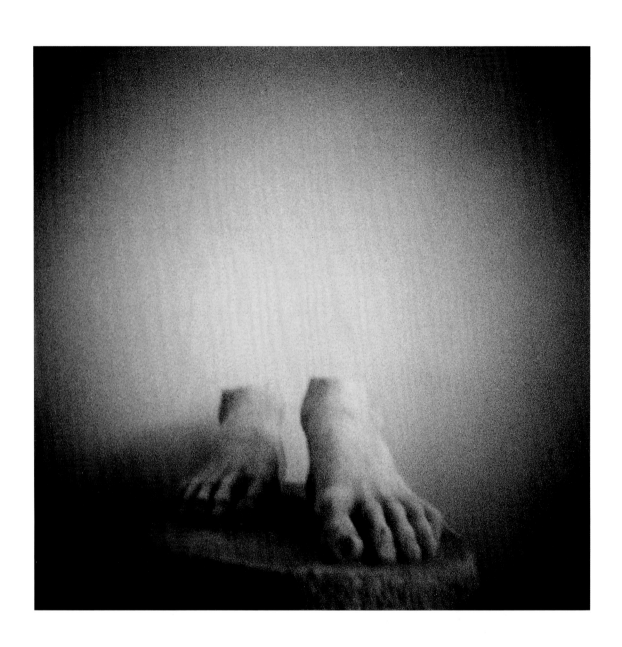

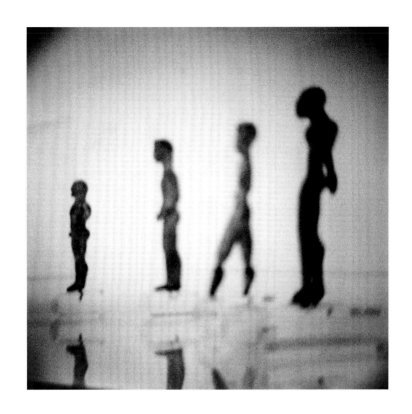

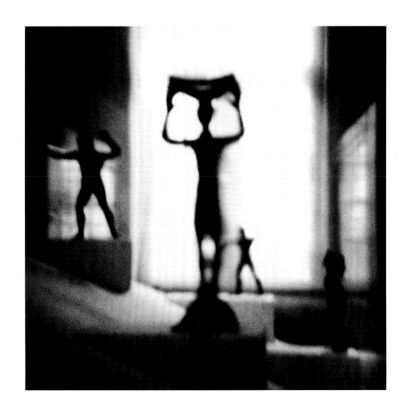

ROBERT STIVERS

Arches

Wrapped Woman

Bust of Woman

DON HONG-OAI

On the River Li, Guilin

Napping Under the Tree, Guangdong

Solitary Wooden Boat, Hunan

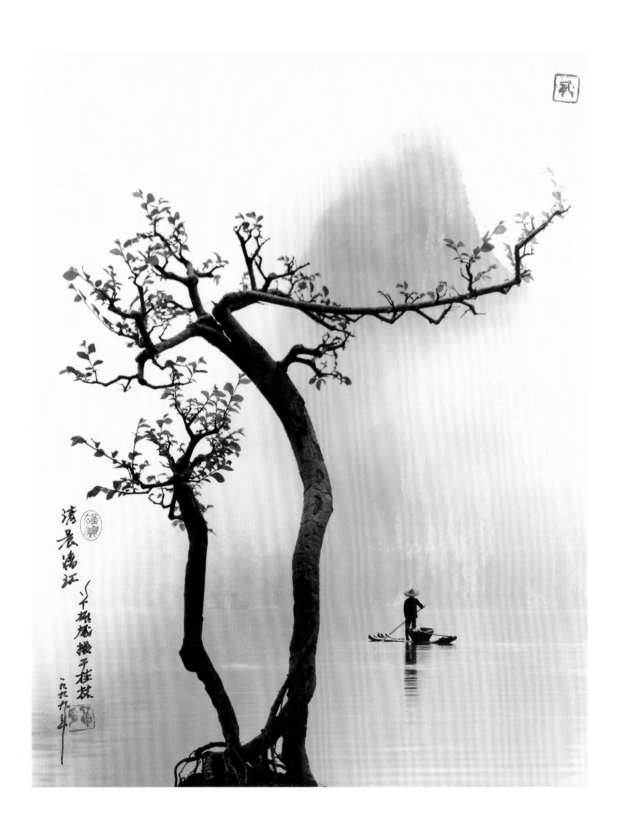

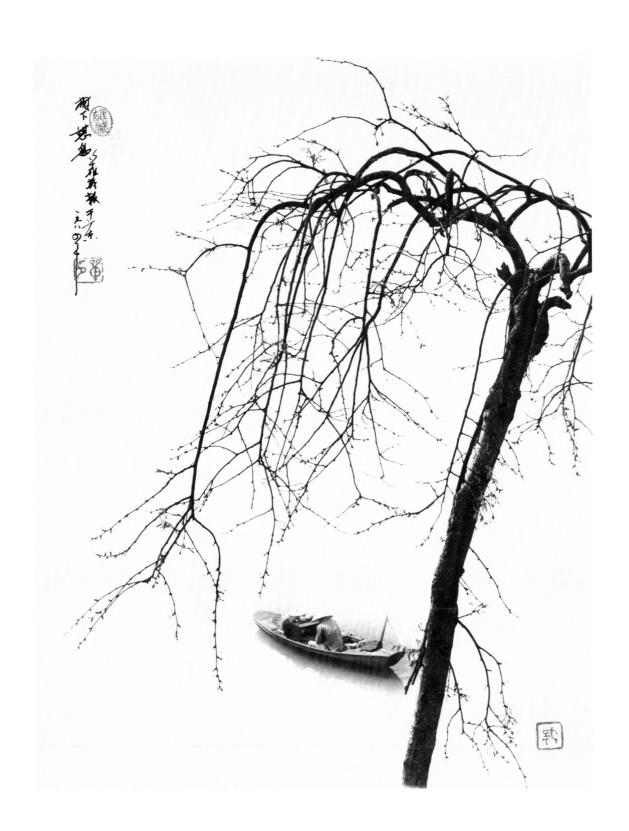

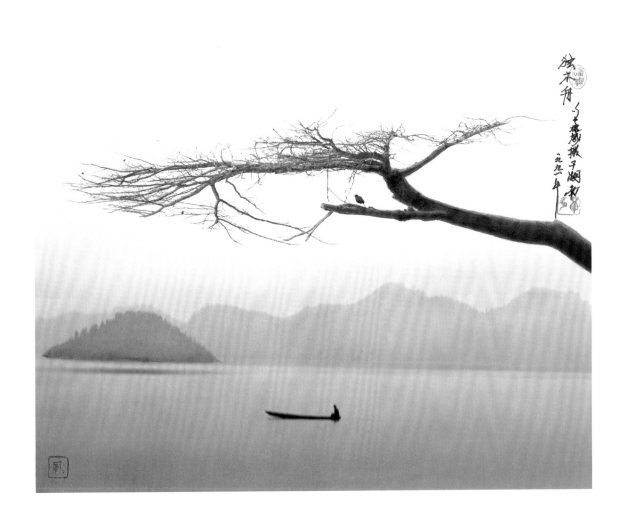

S. J. STANISKI

Mosque de Bani #1

Mosque de Bani #3

Mosque de Bani #4

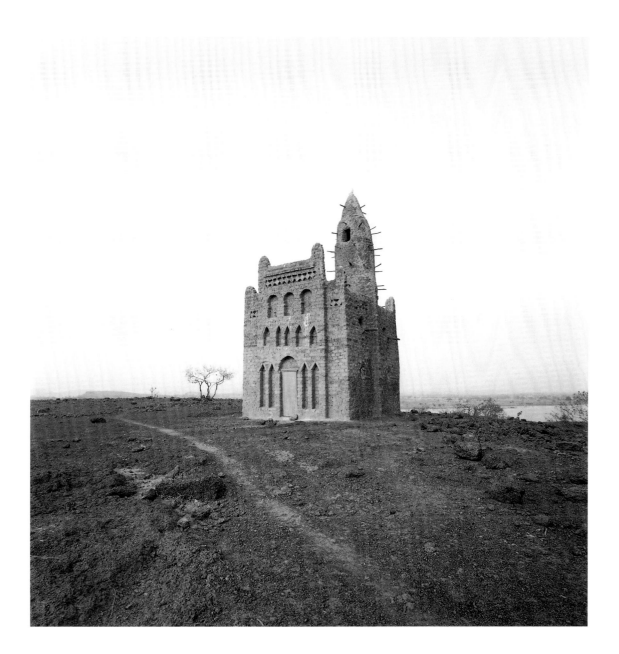

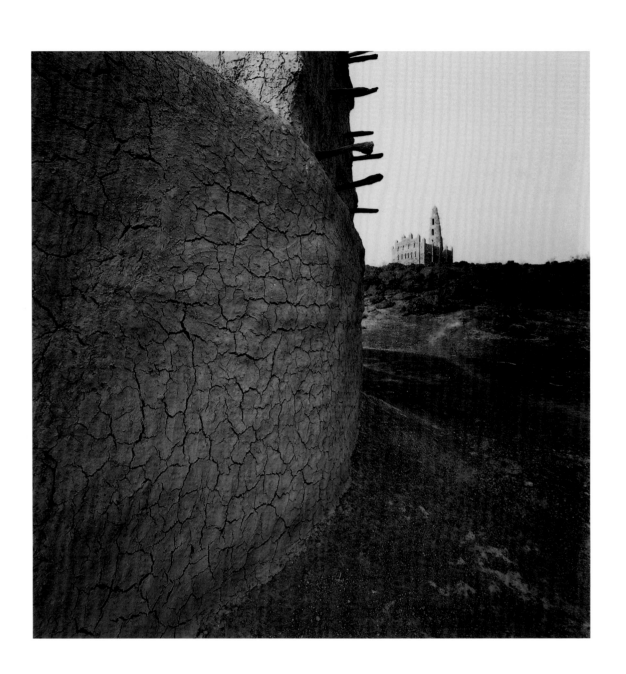

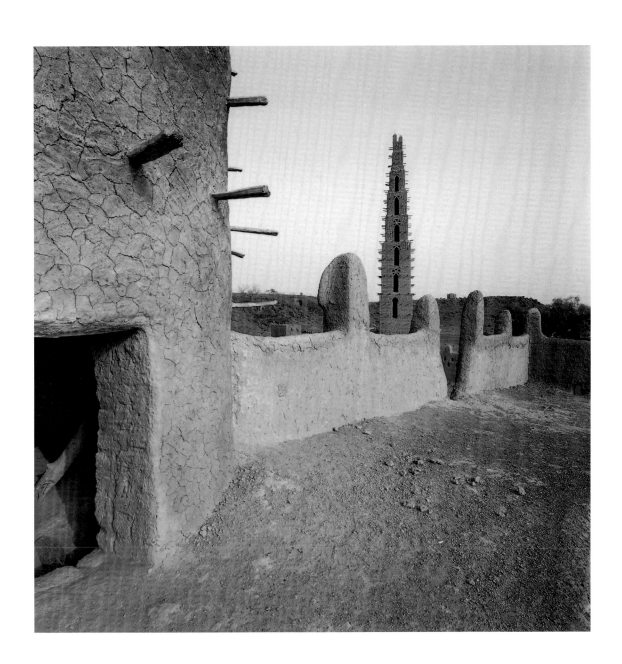

CHISELED TABLEAUS:

The Nudes of Dimitris Yeros

BY PAUL LAROSA

In a moment of unadorned melody—a fragment of birdsong, a Chopin Prelude—
the cords within us bend and turn. Time suspends, and from a single nuance, a world
unfolds. The solitary nude, pure and unambiguous, is a similar melody, one keyed
to beauty and simplicity, a rhythm in which we move in unison. In lowered eyes our
desire is merged; from line and limb we quarry the substance of life and love. Each
gesture of the body is a moment both intimate and vast, a summation of sense and
the lineament of thought.

Dimitris Yeros captures such moments in lyrical photographs that celebrate the beauty
of the male body. His nudes distill an unspoiled essence and vitality, discovering
gestures and nuances in the body that are infinitely revealing and self-renewing. In
their presence, time seems to melt away, and a world of wonder is disclosed, a
world scaled both to intimacy and to universality, in which spirit and flesh harmonize.
Staged to face us directly, Yeros' nudes are palpably real and teeming with presence—
breathing, blinking, pulsing—but at the same time they glow like deities newly
imagined. They awaken us to destinies of love and desire, to origins and intangible
essences, and in their curves resides the intoxication of instinct. Lucent and visional,
they seem brought from the sun, caught by stars, and bent by the moon.

Acclaimed as a painter and photographer, and widely exhibited at home in Greece
and abroad, Yeros has also produced sculpture and poetry, and is one of the first video

artists. All is concentrated in a pursuit of beauty nourished by an amazement for life, an adulation of youth, and a clear and abundant eroticism. Purity and immediacy define his work, and a fulsomeness that is achieved through clarity, simplicity, and play. Yeros' sensibility is ludic and intuitive, embracing the unexpected through gently surreal arrangements, peculiar combinations that imbue his art with originality and an inherent sense of joy—a joy akin to a child who suddenly runs simply because it is possible, for whom movement precedes purpose. Yeros' photos are governed by the same spirit of openness and spontaneity. They may be staged, but they also seem discovered in their own making. They preserve the ephemeral and entrust themselves to the moment, exuberantly.

This is not to say that his work lacks depth or refinement. On the contrary, it is as contemplative and exquisitely layered as it is simple and celebratory, and it innovates a genre choked with solipsistic gestures, too often bereft of substance, feeling, or originality. A lustrous quality permeates Yeros' prints, with tonal contrasts that are richly suggestive, neither austere nor distancing. Symmetrical and precise, with direct and absolute perspectives, his images of nude males appear as chiseled tableaus, and yet their sculpture belies a natural rhythm, a nimbleness and flux. From darkened chambers that resemble both deep pools and the broad canvas of dreams, figures emerge and assert themselves, irradiant and reborn. Fingers uncurl and extend, clutching sides and grasping feet, quizzically exploring the contours of the body, as if each muscle and bone harbored its own hue, as if the body were a kind of mandala. In these postures Yeros crystallizes moments in which the body is a threshold to self-discovery.

On one hand his nudes, statuesque and ennobled, partake of a tradition of Classical sculpture. Rendered in elongated lines, they appear like marbled forms lit from within, kouroses gilded by fire, uneroded and quintessential. Often they rest on draped

tables and pedestals, displayed like frescoes or altarpieces, elevated as icons and artful marvels. We recognize a Classical tradition at work, albeit one that is innovated and revivified. Surreal flourishes abound, maverick flights of the imagination that disrupt our expectations. A boy's torso is covered in snails. The elegant supine pose becomes an arching sprawl, unsure of conclusion. Twisting limbs and leaning postures imitate the symbols and forms of language—alphabets, zodiacs, arabesques. At times, the angled placement of the body seems to suggest the machinations of an unseen puppeteer at work in the background. But the figures are too sensuous to represent dolls, too alive and protean and with gestures too expansive to stand as symbols for the workings of fate. Rather, it is as if his models were released from the temples into the world of the flesh, in which they find themselves vexed by ardor and a new-found freedom, spellbound by a nascent awareness of the body. Their movements are orchestrated yet informal, compelled forth as tides by the cycles of the moon.

A melodious and organic quality keeps these photos natural and intuitive. The props which accompany his nudes seem chosen as Mediterranean icons of simplicity and bounty, resonances of life at its most elemental: apples and lavender, jugs for water, sheaths and wooden tables. Sometimes Yeros pairs his nudes with animals, establishing a kinship that underscores their earthiness and reaffirms our bond with the natural world. In other instances his figures seem animalistic themselves, poised to pounce, transfixed by rut. Issued forth from primal movements and the rudiments of life, Yeros' work is generative and embryonic. It is not exiled from nature, but resident at the very core. I liken it to a pearl brought forth from the depths of the ocean: unique, whole, sensuous and luminescent. We discover this same radiance in the odes of Portuguese poet Fernando Pessoa, with whom Yeros shares a magic joy for the "universal sum of life." Like Pessoa, he proclaims its "sensual passing," anchoring it in images of sparkling purity and simplicity. His art is essentially devotional, and its

lyrical depiction of the body restores to us a vital reverence for beauty and for the essential rhythms of life.

Nothing is decorative or superfluous in Yeros' photographs, and at the same time, nothing is overtly conceptual; the images are essentially associative and imaginatively layered. In one mesmerizing photo, a naked youth, wide-eyed and content, is covered in snails and garlanded with ivy. Painterly and serene, the image is an inspired reinterpretation of the still life banquet, a curious reworking of familiar signs of bounty. But Yeros transcends the rules of any formal game, harnessing an energy that propels the image into the realm of the visionary and the erotic. Like some mythic being, the boy appears newly sprung from the clay of the earth, a living embodiment of the creative force of nature. He emanates a sexuality that is steady and harmonious, a magnetism blended from his tensile limbs, his balanced posture, even from the wet snails that trail across his skin like a succession of kisses. Yeros speaks eloquently to the dynamism of nature, its richness and juvenation. He locates the fantastic within the real, the spirit within the flesh, and as in much of his work, they culminate in an eroticized image of a beautiful boy, an evocation of youth as the sensuous body of the world, fertile and enfolding. We see it again in his photograph of a beautiful young peasant, flaxen-haired and with lips gently parted, who sits naked on a cropping of rocks under a moon-bright sky, encircling a clay urn with delicate hands—a radiant image draped in a mood of expectancy and offering, far removed from any Orientalist vision of exotica. The boy's languorous gaze and the lush chiaroscuro recall the seductiveness of Caravaggio. The image is powerfully erotic, timeless, and peaceful, threaded by a dream of desire and eternal youth. Here is Antinous, the teenage lover of Hadrian, whom Pessoa immortalized in verse: young and golden-haired, and with "eyes half-diffidently bold"; a "flesh-lust raging for eternity," in whose presence "thou wouldst tremble and fall."

The charged eroticism of Yeros' work often rests in dualities that are skillfully balanced: stillness and motion, the hidden and the exposed, the visionary and the vernacular. A photograph of a boy standing naked, arms outstretched and shielding his body with an opaque curtain, strikes us by an understated yet pronounced complexity. The image is a potent, tactile embodiment of lust and temptation, and at the same time it bestows a sense of innocence and evanescence. Yeros' veil, fluid and impermanent—a counterpoint to the immotile stance and stare of the boy—brings light out of darkness, but it also returns us to a world of secrecy and untapped desire. In its folds seem to lie the currents of the boy's inner world—hope and longing, emotional life, love and sex. More mirror than barrier, and with a dreamy texture that summons contemplation, it harnesses our thoughts as well, a gateway to reflections on the quixotic nature of desire and the passing of time, and the irreconcilable exchange between what is attainable and what forbidden, in which all our lives dwell.

Look at his serpentine image of dark-eyed youth, a male Salome with arms raised and body stretched—a brooding, enthralling depiction of male. We recognize a sexuality that is all-encompassing, that translates the full range of human emotion and experience. It is at once calm and devouring, lyrical and raw, and it seizes on all the senses.

For Yeros, love, beauty and desire are celebrated as equal feasts, sustenances drawn from an essential world of plenty. They nourish his art and instill it with sentience and significance. Rapturous and alive, his nudes are keyed primarily to our senses: they stir and reverberate; we shiver, sigh, and tremble. But they also incarnate the fundamental rhythms of nature, like poems tracing paeans to the interconnectedness of life, its abundance and endless possibilities—as if anchored, in "delicious solitude," in the same pungent natural world of Marvell's "Garden." Their erotic presence fuses the earthly

with the ethereal, sex with spirit and sublimity, and it speaks to a kind of perpetual
wonder and veneration that is deeply and commensurately felt. It became all the
more apparent when, as I sat writing this essay one February morning, I noticed a
strange and beautiful confluence of events outside my window, a phenomenon I
have rarely glimpsed: a dense curtain of descending snow, and the sun burning bright
through shifting clouds, igniting the air. I stopped my work and stood outside, a
captive witness to Nature's caprice—an occurrence unique and resplendent, both
detailed and immense, still and dynamic, showing a world wending toward harmony.
"Wedding of foxes" it is called in Japan. When the snow stopped I returned to my
table, and once again looked at beautiful Greek nudes. Surely Dimitris Yeros would be
inspired by such a sight, and would understand, who captures the same resplendent
world, provokes the same sensations in his glorious photographs.

Another Narcissus

after a photograph by Dimitris Yeros

BY EDWARD ALBEE

I'm standing at the table, looking into the mirror. I am liking what I see. I am young; I am handsome; I am pure. I understand why people want me. I want me. My sex begins to harden.

I stand there for a long time. I think it is the moment of my perfection that I wish to record—before change comes, before loss comes.

It is not until the ivy has circled my neck and the snails are nearly to my mouth that I notice—so enthralled am I by this object I see in the mirror.

Eventually the ivy will strangle me, the snails will cover my eyes and make their way down my throat, but I think I will still be hard as I think about the wonder of me.

The Distillation of Lavender

BY ANN BEATTIE

A guilty truth about writing: if you know your subject well, you will never feel assurance about where to begin; only boring subjects offer an inevitable starting place.

Of course I could begin by attempting to describe the person, or the riveting and beautiful images, but to be honest, I am so overwhelmed by admiration for both that I think I'll hedge my bets and try to present Jayne Hinds Bidaut by way of some lines from the poem "Dream On," by James Tate:

> *It's a rare species of bird*
> *That refuses to be categorized.*
> *Its song is barely audible.*
> *It is like a dragonfly in a dream—*
> *Here, then there, then here again*
> *Low-flying amber-wing darting upward*
> *And then out of sight. . . .*

I see her, of course, as the dragonfly. But I see her, as well, as a sort of dreamer: someone who works with symbols, someone whose subconscious does not allow a dragonfly—or a golden silk spider, or a velvet-striped beetle—to escape her notice. Of course, whatever she presents as an image of beetle or butterfly or moth will already have escaped. Dead, it will be positioned, exposed not only to scrutiny but to light, its portrait made.

Jayne Hinds Bidaut is decidedly retro, in a time when so many things aren't seen purely, but tchotchke-ized: dolphins swim not only in "Seaquariums," but, miniaturized and plasticized, rise and fall as you write with your ballpoint pen. Storybooks haven't been enough for us: now, plush animals have to be targeted at adult audiences as well as children. *Faux* animal hides are meant to amuse when stretched over butterfly chairs; plastic flamingoes are less *hommage* than signs for nature's demise at the hand of pink plastic. In the prevailing ironic context, Jayne becomes the purists' purist. Her method is straightforward, though what emerges defeats any expectations we've acquired from high school biology textbooks because her process is tintype: each print emerges with variations, making it unique.

Nothing she depicts is doing anything cute. Look at her book, *Tintypes*: the Lepidoptera and Coleoptera are centered on the plate, facing upward, like icons. If they walked again, reborn, they would be oriented toward heaven, not toward us. Fingerprints, variables of chemicals, specks of dust express the variations that emerge as the result of processing, while the orbs that brighten the area around the subject evoke the creature's growth process in maturing from egg to insect. We are reminded of the process of mitosis as we look at the speckled irregularities integral to the picture. These are not Jeff Koons' ironic animals—they're dead serious, alive in the imagination.

Who did I expect to meet? The Annie Dillard of photography, I guess. Someone very original, therefore almost certainly disarming. A small woman, intent upon dignifying small beings. I had her dressed in black (New York City), guarded in a deceptively conversant way (New York City). I hadn't seen anything in the images to suggest a sense of humor. Previously, she had very kindly sent me her book, *Tintypes*, and I'd also looked at—but deliberately not read thoroughly—various press

clippings. Though she was working without knowledge of what other photographers were up to, in terms of resurrecting printing methods, her work, when it emerged, occasionally came to be grouped with a small number of photographers whose common bond was that they had begun to revive various old printing processes. Their philosophies, of course, were different. In Jayne's case, it was the verge of the millennium, and she felt a protective impulse toward the old processes, themselves. (Had other photographers not had similar interests, she might not have been able to find the necessary chemicals.) She was also rebelling against the digital age, and all the people who urged her to look forward, instead of backwards. She was dignifying the humble, as well: the humble tintype—quite distinct from the daguerreotype, for which people dressed up in their fancy clothes and posed for posterity—and depicting, with the procedure, things she felt had an inherently un-glamorous image. I had read up on tintype, which contains no tin. (This seems to me no more or less remarkable than so many recent fictional texts appearing as memoirs.)

Enter her SoHo loft: a beautiful, almost tall woman with pale golden-red hair, a gold necklace, and a very welcoming manner. Not dressed in black. She is almost alarmed that I don't want anything to eat or drink. A turn-of-the-century English Mammoth plate camera, originally for glass plate negatives (which she uses 20 x 24) just behind the entrance area that makes me feel like a Lilliputian. Her assistant not yet present. Bamboo sprouting from a vase filled with red marbles. A fish-shaped lamp—Wow! *The very same fish lamp I have!*—which leads us into a discussion of the curiosities of Vietnamese gift shops. It's not long before the two of us are bent over one of many terrariums. Insects, at first indistinguishable from their stalky natural habitat, stir when the top is raised. She sprays. Teeny, tiny (I put on my glasses) mouths open. A few extra spritzes of the wild rose branches, for good measure (these, delivered from a grower in California, because in the winter she can't easily

grow all her own food, such as raspberry and wild rose bushes. Naturally, they come without the pesticides that would kill the inhabitants).

She's immediately engaged, half talking to herself, half talking to the creatures in the terrarium—with enough of a sense of detachment, though, to see the humor. And all of it is very gentle, in the same way that her tintypes seem very respectful. Reverent. *Fragile* is another word that comes to mind when viewing them. Most people wouldn't like an insect crawling up their arm (Jayne would), but when she creates a tintype and puts distance between subject and viewer we can safely examine perfection and imperfection. Mercifully, they're too detailed to tempt you to look at them as a Rorschach test: they indicate a lot about themselves, and not much about the viewers' orientation toward the world.

When I hear a dull *clack, clack*, I assume that the heat has come on in the loft. But no: it is "Lizzie," awakened from his nap. Rescued by Jayne some time ago when he was obviously down-and-out, malnourished and ill, the iguana drops a leg casually off the windowsill. Lizzie has been sleeping on a bed heated by two heating pads and a chenille throw (burgundy) on top, with an assortment of soft little stuffed toys to serve as pillows.

Jayne and Lizzie (sense of humor, definitely: the iguana is featured on the annual Christmas card, including a pose as a Christmas tree ornament) take road trips together. Lizzie's favorite head-rest was found in a gas station in Texas.

I reflect that—as in her photographs—when you spend time with Jayne, there's a sense of surprised discovery. Things gradually reveal themselves, the way protective

coloration gives way when an insect moves. Who would suspect that an iguana lay underneath a cover on the windowsill? Other treasures are only seen when brought forth—though a little box of soil, leaves and moss that must be some creature's plan B environment seems downright tame, if a bit mystifying. You have the feeling that while most people couldn't exist without their credit card, Jayne couldn't live without her misting bottle.

She has loved animals since they were her childhood pets. Her father, an engineer, would sometimes bring home baby bunnies that had been driven out of their natural habitat, or even "Bobwhites in a Baskin-Robbins container." He figured right when he thought his daughter would be the one to love them. "*Wild* animals," she stresses—as if those are even more precious (of course, it's clear from her art that she *does* like happy accidents). Flip forward from then to now, when she is preparing to have a show at New York City's Museum of Natural History: 25 of her tintypes, with accompanying insects ("Then you can see their colors," she said excitedly. "It's great for kids *and* adults."). I feel sure that she will be there when they hang the show. Every aspect—every detail—is seen by her as part of the whole. Even the labels on the back of the framed artwork have been arranged for by Jayne, who found the Japanese paper, then located a letterpress printer who printed the typeface she chose, using her design. When questioned, she is casual about the way this came about ("Oh, I found a letterpress guy"), but it's another example of her vigilance, her sense that something is not complete until it can be observed in its entirety, front to back, with everything that pertains cohering. As with magic, if the magician lets down her guard for even a second, everything can be lost.

The images are very of-the-moment, and absolutely uncalculated. (Of-the-moment having to do with a close examination of the physicality of bodies—not so far away, in another kingdom, are John Coplans and Holly Wright.) But who can fake an obsession? Exhaustion would win out. The sheer number of possibilities Jayne surrounds herself with—alive and dead, hidden and lazing—makes her the real thing. She now wants to use in her photographs only plants indigenous to Connecticut (where she also lives and works), not just any pretty dried flowers or leaves. In the finishing process, the tintypes are coated with—among other substances—fragrant oil of lavender.

If she doesn't grow lavender already, wait till spring.

In "Richer Entanglements," Gregory Orr speaks of the lyric poet's heightened awareness of the body as the locus of the conditional world he wishes to escape. He writes: "The more intensely the poet feels the body, the more intimately he knows it, the more he longs for that 'flight' which is born out of the body's anguish."

In a way, Jayne Hinds Bidaut is writing lyrical poems. Certainly she has examined anguish (the animalerie; the plight of her formerly abused companion Lizzie; the photographs of sad-eyed animals in pet stores). What artist doesn't hope to offer transcendence—with image, painting, photograph, music? It's creepy to feel you've "captured" anything. The idea is to catch something only long enough to let it go. That's why writers look blank-faced when people tell them, "You've captured my own family perfectly!"

On February 3, 1847, there appeared in the *Sandwich Island News* observations about a suddenly hugely fascinating new process that allowed one to have his or her image made, inexpensively and quickly, to be kept or shared: it was like having your own playing card—the ace, of course—and the only question was how you'd play it. The daguerreotype: give it to a loved one? Keep it hidden next to your own heart? Use it as a painting reference? The publication noted: "the Daguerreotype mania is at present the most prevalent among us. Instead of the ordinary greetings of the day, people inquire whether you have 'been taken yet?'—questions which, in the uninitiated have a somewhat ominous sound."

Today, a question about whether you had "been taken" would probably have to do with buying the wrong car, or waiting for the triumphant finale of a David Mamet play. I'm only being slightly facetious; of course we are on guard, more than a century later. And we have progressed (if it's a progression) from finding meaning in formal portraits to trusting less formal revelations of character (or, more accurately, we appreciate the illusion that that's what we're looking at). We're also more audacious, and find it necessary to zoom in on details, to purposefully distort in processing (to say nothing of the manipulation that can be done with the computer). The political statement is all-important. But then, how can you lose, when the new twist on narcissism is that the personal has ostensibly become political?

I look at small chromes of animal parts that have been discarded at the end of an outdoor market in France, now become sad still-lifes. These are in color ("My little Flemish still lifes"), never printed because she hasn't yet found the appropriate color process to match her vision of how they should be. They're shocking but oddly beautiful: "found moments," neither contrived nor re-arranged. As you might

expect, Jayne does not kill her subjects. She buys from "the insect guy." She has procured many, many of them. I look at one encased in a tiny plastic tomb as if it's a Benadryl capsule.

She also gives me one to take away: a little insect in plastic, dropped in a film container for further protection. I suddenly remember that years ago, I bought film canister salt and pepper shakers that were a great hit with my friends. I also remember, and do not mention, that thirty-some years ago, a friend gave me advice. As with much advice of any value, it was a non-sequitur: "Always take the picture when everything's over, and never buy a house from anybody who's put in a stained glass window."

The development process results in tintypes that are both distinct and indistinct: details are there—if not missing from the original, that is—but there's also the feeling that each subject, like Lizzie, has found a very comfortable resting place—textured, perfectly imperfect, not in anyone's absolute control, including the photographer. From what she wears to what she chooses to surround herself with, it's clear that textures and surfaces, accidents and little oddities—are integral to the desired effect.

The photographs also make us stop to wonder, as did Robert Frost, "if design govern in a thing so small." There's a spiritual element. A symbiotic relationship between photographer and subject that is palpable—to such an extent that Jayne once kept an almost infinitesimal mouse that fell out of its nest prematurely warm inside her brassiere.

At once informative, curious, suggestive, and even erotic, we view the tintypes as their own complete environment in which each specimen has its own integrity, its own

selfhood. And let's face it, outside of the context "lepidopterists' studios," once you've graduated from high school, you don't see these things. If you do, you probably smoosh them. The idea of examining them is sort of . . . strange. It's not strange to get a telescope to see the stars, but it's strange to have a microscope at home (or the photographic equivalent) to examine, say, a giant water bug. Confrontational images? Sure—but obsessive attention can transcend eccentricity, carrying us poetically into necessary fact. In demanding nothing of us, a water bug can be more like the stars than we might think.

Jayne is her own model for the draped nude *Academie* poses. This is because she knows exactly what she's after. As she explains, "When you photograph someone, it's a collaboration, but only I truly know what I want." She's also sensitive to the difficulties involved. "I wouldn't want to do that to anybody—make them sit still for seven minutes."

I like to imagine those 420 seconds (fiction writers find it necessary to stretch out possibilities) in which the subject is transformed. How would this happen differently in a science fiction movie? The camera could speak to her like Hal. In a children's book, every trinket in the house could become animated to help pass the time: fish lamp winking; red marbles rising out of the vase like fire roiling from a volcano. Holding still for the present, to be seen in the future, while giving a nod to the past . . . this responsibility obviously makes me nervous. Is her phone on or off? Does music play? Is anyone else there? Geoffrey Dyer, in his brilliant book *Out of Sheer Rage*, points out that "in the age of the computer, writers' studios . . . increasingly resemble the customer service desk of an ailing small business. The artist's studio, though, is still what it has always been: an erotic space. For the writer the artist's studio is, essentially, a place where women undress." So I have photographer's-studio

envy, but while I'm supposed to be good at inventing (the phone *does* ring!), I'm stuck. One's thoughts upon actually disrobing, as opposed to "revealing" oneself on the page? They're too different to make anything except a specious analogy. Understanding a moth's resemblance to the female form, then adding appropriate drapery to define one by way of the other? Much harder to do that and be convincing visually, I think, when—without the malleable protection of words— a succinct image could inherently disintegrate into a joke (see the cover of *Tintypes* for proof that it does not).

Her images—whether of human, animal or insect—are beautiful, displaying the precision of forms, the expressiveness of some essence as difficult to pinpoint as the soul. The photographer, too, has a delicacy about her: the Merchant-Ivory-would-swoon upswept hair; the way she looks intently at something before touching it. When she does extend her hand, however, it is without hesitation: it would be wonderful if the spindly insect climbed onto her finger. But if it does not, she clearly still feels something of its spirit internally: look at the folds of material in the *Academie* photographs, her face more often obscured than not (it isn't an insect's *face* we focus on), arms-as-wings, her not fragile body that, cloaked in her compatriot's wings, nevertheless contains the energy for flight.

I have just found out that she not only grows lavender, she knows how to distill it.

What But Design of Darkness to Appall?

BY LEE FONTANELLA

At the close of Robert Frost's sonnet "Design" about the poet's discovery at pre-dawn of a "snow-drop spider" in its web holding up its prey, a white moth, first two questions, then a tentative answer to those questions, then a vacillation about that answer are put to us.

> What had that flower to do with being white,
>
> The wayside blue and innocent heal-all?
>
> What brought the kindred spider to that height,
>
> Then steered the white moth thither in the night?
>
> What but design of darkness to appall?—
>
> If design govern in a thing so small.

What brought these particular elements together in time and space, in order to create this particular natural phenomenon, if not darkness by its own design—that is, "if design govern in a thing so small." Maybe the pregnant word in this marvelous poem is "appall." (Grammatically, "appall" can be both transitive and intransitive: things can be caused to grow pale, and things can wax pale.) Is the design of darkness paradoxically to turn things a visible white, to be a background so that the poet can appreciate them in apparent whiteness (the heal-all on which the spider has woven its web has color by day but is whitened in and by virtue of darkness)? And when the poet comes across the natural phenomenon, does he, too, pale at the sight?

This exquisite sonnet, written just a century after Fox Talbot secured the results he called photogenic drawings (1835) is concerned with the appealing paradox of Appalling Darkness that so caught Frost's attention and which—I am tempted to think—probably made him wax pale, too. It causes me to wonder if Fox Talbot might have seen in his photogenic drawings a good bit of that same appeal; that is, the appeal of a darkness that brings about a stunning pall, to the point of illumination akin to intellectual enlightenment. I wonder, also, as I wonder in studying the photograms of Anna Atkins, if the earliest photographers saw the design in what they wrought, or else in their subject matter. Surely, they are seeing things differently, and that implies seeing new things, more intricacies, as well. The world grew increasingly reified, I think, for the early photographers, and, as for Frost a century later, there may have occurred a lovely confusion about where Design resided: in the "drawing" or in the subject drawn—"if design govern in a thing so small." Similar to the way in which this line gives the sonnet its most profound dimension—a dimension perhaps more chilling than the resolution (Appalling Darkness) about the poem's metaphysics—Fox Talbot and Atkins surely perceived a governing design in their subjects, in addition to recognizing the governing design latent in their own art. (I may as well have said "in their science," for in that "witches' broth," which Frost referred to in his first stanza, the ingredients were almost indistinguishable.)

For me, there is a cousinship between early photogenic "drawings" and the poems of rustic New England that Frost artfully cultivated, converting chance, earthy bits of New England into unique samplings, each and every one almost a celebratory revelation. Both hail a newfound thingness and thrill to the experience of it, to the point of near spiritual change. This serves to introduce the way in which I understand the photography of Christopher Bucklow: comparably huge photographs, now, although many of them also contain chance bits of the universe, and, most notably,

they reveal—they lead to spiritual truths— as they afford the photographer his training in seeing and comprehending. Christopher Bucklow's photographs enhanced his understanding of both Other and Self, outside and inside. I would venture to say in retrospect (although the diction hardly applied in 1835) that Fox Talbot's—probably also Atkins's—confessed heightened capacity for seeing things must have contributed to heightened comprehension of the self in respect to their photographic subjects.

I further suspect that the photographers of today who are re-exploring the technics— those fundamental principles—of pioneers such as Fox Talbot and Atkins may have at least a tentative answer to Frost's poetic query ("What but . . .?"). Scientifically speaking, Fox Talbot, had he heard the poet's query, also could have responded to it. But the photographers of today who are re-exploring fundamental photographic technics surely can.

Others' remarks on Christopher Bucklow's photography, in addition to Bucklow's own remarks on the photographic work of his friends and colleagues Adam Fuss, Susan Derges, and Garry Fabian Miller, lead us to know that these philosophical preoccupations over the relation of the Self to Universe are in fact central to their work. Having speculated as I did about those who wrought photogenic drawings in the 1830s and 1840s, it is not surprising that a considerable portion of the work of these modern photographers harkens back to the methodology of the earliest photographers. Although Bucklow used a camera (of his own fashioning) to obtain his "Guests" and "Tetrarchs," his concern for the Sun as both agent (delineator) and subject (delineated) is evident. In this, he, Fuss, Derges, and Miller are of a kind. Also, they seem to be in keeping with the so-called Land Artists like Charles Ross or James Turrell, whose astronomical concerns likely are related to their visions of Self. When Bucklow, Fuss, Derges, and Miller exhibited together at the Fraenkel Gallery

(December 1996–January 1997), Jeffrey Fraenkel's opening remark was "There is something in the air," and he went on to note the exhibitors' common "deliberate engagement with the metaphysical possibilities of the medium," as they dealt in "photography distilled to its basic elements." I think that Jeffrey Fraenkel had something there: all, at the same juncture in photographic history, appeared to stretch photography by reinvestigating its early functions, and by so doing to investigate their respective Selfs. While these new renderings of photography are wondrous insofar as they represent the current technical and esthetic stretch of what may (wrongly) seem "primitive" to us now—but which, in 1835, was probably even more wondrous than what we are now perceiving—they are not just the marvelous results of technical experiments, rather means to profound investigations into the human agent behind the photography.

Evidence for this claim is pretty abundant. For Christopher Bucklow, it is there in his intelligent insights concerning his own and colleagues' work. (By the way, not all makers-of-images have the extraordinary capability that Bucklow does have of being able to articulate what he and others are doing and why, as they engage in image-making.) His "Guests" series is a cast of characters who have appeared to him: in dreams, as integral aspects of the Self, as aspects that the Self might incorporate, or sometimes even as foes ("the brightest ones, burning with intense radiation," Bucklow told me). Positive or negative "forces," they reappear photographically by Bucklow's invitation. They are, after all, Guests. David Alan Mellor, who has written on Christopher Bucklow's work, has spoken of the Guests such that they "announce themselves to the profane universe." In all of these concepts, the rhetoric draws my attention. These Guests are self-revelatory fundamentally. They just appear, they auto-announce, they show themselves as particular elements of a more complete entity, which might be the integrated or the eventual Bucklow. In order to be self-

revelatory, there must be means of revelation, an illumination that is a means of enlightenment. And in the means, we may discover another "appalling" design of darkness, even conclude (although Frost chose not to) that Design does govern in a thing so small.

Every photographic Guest—to distinguish them from those who might have appeared yet photographically unconcretized, in Bucklow's imaginings—begins with a tracing onto foil of a Guest's silhouette. (In this sense, I am tempted to think of them as incorporative of image-making that antedates photogenic drawing by another century.) Bucklow then laboriously, not randomly, makes thousands of pinpricks in the foil, through which light will eventually pass to a sensitized sheet. (All backgrounds apart from red or yellow are natural colors; red and yellow are produced by filters.) Colors can signify, but the amount of radiance achieved through pinpricking, including haloing, may signify as well. Bucklow varies the widths and frequency of the holes, depending upon the amount of light that a particular portion of the Guest should absorb in order to signal a certain quality or tone of the Guest, thus allowing the Guest to appear to emanate the light in return. It is in this illusion of consequent illumination on the part of the Guest, of this being a galaxy of suns, of the Guest's re-diffusion of the light by which it was created, that I personally find the surpassing of the earliest photography, insofar as early photography was made to satisfy other ambitions.

The rhetoric behind early photography tells us that it aimed at Truth. Fox Talbot, for example, found that the multitude of minutiae contributed to a truthful and real depiction, and that accidents of light and shade, which might not be rendered by the painterly hand, would likely contribute to the realistic result in photography. In photographic representation, quantity (not just quality) of details depicted seemed to

be no longer a bothersome factor. The figures of speech betrayed a metaphorizing of the technology that has antique appeal to us today: the camera made an image of what its eye saw; it chronicled reality; objects, such as buildings, drew pictures of themselves; etc. The aim was the "accurate" tracing of a reality that was always outside of the photographer, although it was often the photographer's vital context. All in respect to the sun.

Bucklow's Guests become galactic, multiple suns, once their silhouetted forms have been exposed. They lend the illusion of having absorbed only to give back, doing our sole sun one better, by becoming infinite suns. They not only soak up, they emanate light, and, within themselves, they diffuse light with apparent ability to underscore portions and implicit qualities in themselves, when actually that "ability" is a ruse that has been predetermined by the painstaking pinpricking that is just prior to the photographic act. Christopher Bucklow has told me that haloing and extraordinary radiance in the form can signal a harmful Guest, not necessarily a generous one; nevertheless, these effects are achieved through the appearance of returning light, through a Guest's becoming a galaxy of stars. He has told me also that in his sharing of his Guests with viewers, he attempts not to allow viewers to know if the Guests are staring at or staring away, whether they are coming or going, arriving or leaving. I have inferred that this is a way of sharing the Guest, allowing viewers in on the mere presence or existence of the Guest, without being able to determine the precise status of the Guest within Bucklow; that is, as an aspect of his being. Whether Guests come or go, he retains them in this way, while he shares them with us.

This pertaining on the part of a Guest, while rendering something as well, is analogous to the nuclear fission/fusion metaphor that grows progressively central to Bucklow's work. Certain of these Guests are his most esteemed friends; for

example, an upside-down Guest, Matthew B., an individual whom Bucklow admires as much as he does William Blake. I suggested to him that the upside-down Guest, with the brilliance still in his head despite his head's inverted, low position, is a way of insisting on the illusion that the Guest is the origin, not the result of light. Bucklow agreed with this, and I take it as further substantiation of the illusionary reversal of the physics of light, which constitutes these Guests.

What is more, the cast of characters has an interactive life among themselves, the photographic result of which is the Bucklow series called "Tetrarchs," in which Guest-like beings interrelate, sometimes with just a hint of that. "Tetrarchs" are, by literal definition, subordinate rulers. Maybe a bit less dramatically, they could be thought of as cooperant sovereigns, commingling, possibly in different fashions, toward a single end. That end may be thought of as the completeness of the artist, but an artist in a never-ending process of self-making.

This process that is defined by Guest/Tetrarchs images is analogous to a fission/fusion process, for it has to do in the most fundamental way with another of Bucklow's photographic thematics and, at least as basically, with the non-photographic art to which he has dedicated himself in most recent years, and which has earned him a distinguished place as Artist in Residence at the British Museum. (The "Nuclear Power System" is Christopher Bucklow's own tag; a frequent metaphor in which he has invested himself scientifically.) That process—analogous to the process of decomposition/synthesis or, in other terms, being done/undoing/redoing that is the dynamic of the personality of the artist—is Hegelian. It promises that in the studied cultivation of the particular, we have the eventual promise of the whole. The Tetrarchs, for their interactivity within circumscription, are the hypostatized images of the move toward integration of the Self, involving the Guests that are the particles of that

Self. The "progression" from character to dynamic drama is manifest in the Tetrarchs, cooperant sovereigns of a potentially integrated being. Ironically, "fusion" as a phase occurs only upon the withdrawal of the artist's projection of Self onto Other, partly to negate by recomposition a fission that had occurred. So, a denial of Self, while apparently generous, is also necessary for Self's restoration.

Christopher Bucklow surely knew as much when he wrote (early 1993, *Between Sun and Earth*) his presentation of the works of Susan Derges.[1] He saw her work, too, as a process, through which the artist was passing, with a desire to understand the place of consciousness in the world, the place of self in nature. Photography was the means by which this achievement would come about. Cleverly, Bucklow resorted to a theory of Romanticism, in order to explain what he saw as dynamic in Derges. Initially, a relatively "insecure" (his term) participation with art, whereby the photographic activity might be taken (rightly or wrongly) to indicate a certain "absence," a standing off, maybe a hesitancy. That photographer "minimized her agency"; at least, lent an impression of so doing. At that point, the photographer might be taken as facilitator, the balancing point between the exercise of reason in one's creation and the putting to sleep of reason (standing off), such that the natural in us appears to be true author. In Derges' series called *Full Circle* (where Spawn is the central metaphor), said Bucklow, the role of the artist's Self in the world is at last resolved.

As I said, Bucklow possesses that talent (not all that common among artists) of knowing how to talk about art-making, even when it is close to his own; even when it is his own. Christopher Bucklow's words on Derges caught my attention, probably because they reminded me of that Hegelian notion that the theoretician of Romanticism, Morse Peckham, espoused throughout his intelligent, helpful writings. His theories had an extra edge, maybe because they came about largely in relation

to the broad and scattered field of Literature of different (Western) cultures; they addressed, as well as literary art, political realities of the Romantic period. Namely, following a period of outright Rebellion, there would occur some resultant degree of Alienation, and a third period of Reintegration. As Christopher Bucklow saw, the Reintegration is the ironically happy resolution following an Eden undone, an end to be striven for in the Adamic myth, which acquires its dynamic from errant action that is resolved eventually, following real struggle. The decomposition/synthesis dynamic, the fission/fusion process, is weighty in the story of the search for Paradise lost.

It is very present in the art of Christopher Bucklow, not just incidental in his essayistic presentation of the work of his fellow artists. The dynamic of the "nuclear power system" is graphically metaphorized in his beautiful photographic "designs." While they are not a visual representation of human forms, they are meant to represent the nuclear dynamic of explosion/implosion, fission/fusion, expansion/contraction, etc. This is achieved through the creation of forms that are concave/convex, that appear to pulsate, beat like hearts, gyrate on axes, twist onto and outside of themselves. Sometimes corresponding portions of the designs are not exactly symmetrical. Sometimes lines we expect to connect do not, and their breaks, hardly perceptible, amount to small deviations that connote both humanness and dynamism; a thing in continual process, the improbability of completeness. So, they are not just forms that signify the dynamics in Guests and Tetrarchs; they reference their imperfection, insofar as they are incomplete in their act of dynamic becoming. This consummate dynamism implicit in these design photographs suggests, I think, the cinematic version—or potential, at least—of early photography's stilled microcosms.

Factors that are in violent (nuclear) motion are certainly evident in Christopher Bucklow's most recent (and non-photographic) works. In this sense, they too

display an illusory, purposeful kineticism. In one, for example, the being 'Fju:zan (Bucklow's approximation of the phonetic spelling of "fusion") carries out the task of stoking reactors, Bucklow explained, so that fission would proceed apace. Nuclear dynamism is enhanced in the drawings, and it even looks more vengeful or desperate. However, it is entirely related to the quieter Guests, Tetrarchs, and designs, inasmuch as the beings in the drawings, such as this one, may effect a fission that foretells by implication a happy result, fusion. Bucklow himself likes to speak in terms of a *felix culpa*, an Adamic error and resultant condemnation, which looks toward a process of integration that is "fusion." This notion, which repeatedly comes up both in Bucklow's art commentary and in his conversation about his work, is an indicator that he is not one of those artists like Ray Johnson (1927–1995) or Harry Crosby (1898–1929) who equated Life, Art, and Death—in spite of the violent "fission" that is operative representationally in the drawings. Despite appearances, the optimism resides in the fullest sense of *felix culpa*, which looks to the Light, if not to Paradise.

In post-Romanticism—in French Parnassianism, for example—brilliant light, radiance, got over-estheticized and drew criticism from anti-Parnassianists precisely for that reason. Eschewing projection into the work of art, Parnassianism's effort was to stupefy the perceiver's senses by dazzling them, not by light itself, as Turner or Sorolla, for example, may have attempted; rather by light reflected (in both Literature and Painting) off jewels, metals, and the like. The natural consequence of this, in the words of those who remained still affected by the more purely qualitative use of light, was to accuse chief Parnassianist poet Leconte de Lisle of creating works comparable "to the Great Pyramid, which is composed of innumerable small, dirty stones, all alike, whose mass effect is overwhelming." In visual art, the parallel would have been the works of Gustave Moreau, whose artistic shibboleth, "*la richesse nécessaire,*" implied contrivance. It is phenomena of light of this sort that are alien to the work of the

modern photographers such as Bucklow, and it was certainly alien to the earliest
photographers, for all of whom light is so pure, so finely qualitative, as to be almost
metaphysical.

It certainly has a figurative charge. When Christopher Bucklow wrote about Garry
Fabian Miller's work in late 1992, he fixed on the closing stanzas of the third canto of
Dante's *Paradiso*:

> *La vista mia, che tanto la seguio*
>> *quanto possibil fu, poi che la perse,*
>> *volsesi al segno di maggior disio,*
> *e a Beatrice tutta si converse;*
>> *ma quella folgorò ne lo mio sguardo*
>> *sì che da prima il viso non sofferse;*
> *e ciò mi fece a dimandar più tardo.*

> Towards Beatrice's self I moved me turning:
> But on mine eyes her light at first so blazed,
> They could not bear the beauty and the burning:
> And I was slow to question, being amazed.

Paradise regained is in the Light, in effect, a heralding of Truth and Good. (It should
be no surprise that Christopher Bucklow's firstborn bears the name of Dante's
beloved.) The paradisiacal radiance that I see in infinite multiplication in Bucklow's
Guests and Tetrarchs is to him, I surmise, the start on a path to enlightenment,
enlightenment concerning the Self, which always aims at reintegration, a bit in spite
of and a bit by way of the interactivity of Tetrarchs. For us perceivers who, of

course, are not Bucklow, the galaxy of suns that is each Guest renders an esthetic effect, while for the artist it is a step in a protracted process of becoming that, again, recalls the tripartite Hegelian dynamic on which Morse Peckham hung his interpretation of Romanticism. As friends of the artist, we can only hope the process is less painful for Bucklow than for the abject Romantic.

I suspect that it is in fact a joy. Christopher Bucklow once told me that he was thrilled with surprise to discover, while photographing in Venice, that the cross atop San Marco appeared in every one of the solar images of a Guest he made. Images of Susan Derges' visage show up, each different, strictly speaking, in the droplets of water that are caught by strobe before her faint face in the background. When photographer Keith Carter looks into his *Wishing Well* (1998), what galaxy does he find "down there"? For all of these photographers, and for Miller and Fuss, but especially for Bucklow, partly because it is comparably more verbalized there, partly because Bucklow makes no bones about these "characters" being portions of Self—for all of them, the Sun is the great "writer" of worlds out there. In this, they do homage to the earliest photographers. All make the solar source turn into high esthetic.

Since every pinhole that is made to yield a particle of each Guest is acting as a lens, every hole focuses an image within the outline of the Guest, so that the Guest becomes in effect an agent for the return of thousands of sources of light. In this marvelous illusion that the Guest is Source of light, not merely desired represented result (as would have been the case a century and a half ago), rests the hush paradox; a beautiful historical contradiction that appears at first blush to be a technical reversal. Respecting the rhetoric of early photography, what comes "to draw itself," not only self-represents, but even self-proclaims, as if it were willful, perhaps more

willful than the artist. And in so doing, it goes a step further, insofar as it seems to be a represercer of what is outside of itself. By that token, each Guest (by extension, each character of the Tetrarchs) is Self and Other, the particular within plenitudinous context. Understood in this regard, each Guest is not only an aspect of the artist, but also functions in emulation of the artist, insofar as each infinitely particularized Guest seems to strive to reintegrate itself into the plenitudinous otherness that it announces thousands of times (and all at once) is out there. Infinitely fissioned being seeking fusion with the larger whole that it tacitly heralds, by virtue of visual "reflection."

In effect, Bucklow divests that Sun of its integral quality, causing it to go through a process of fission/fusion to parallel his own. I think we must ask ourselves if the earliest photographers did not pass through much the same experience—in all likelihood with less consciousness and preoccupation about it—when they stilled the world around them in particular images; "framing," in effect, the bits and pieces of their mundane contexts, thus threatening the integrity of their personal worlds, which had been their philosophical legacy for centuries. They must have been fulfilling, also, the comparably uncomfortable psychological and intellectual trend that they were born into, a rational impulse to undo the presumptions of integrality that Reason had already interrupted. (None had cause to be a Dr. Frankenstein, who warranted theological concerns about his empirical investigations.)

Nevertheless, these photographers today, while doing homage to their forebears in the re-experimentation of their early science, and being the questionably enriched heirs to Romantic sensibilities, do seem to delight in their results on both scientific and esthetic grounds, even while they may apply photography in dynamic acts of their personal becoming. Frost probably experienced something like this when

he came upon the snow-drop spider; when he recognized that only by virtue of the darkness could he appreciate the stunning pall of the scene he witnessed. Similarly, the apparent simplicity of the radiance that projects in such a seemingly facile way from Guests and Tetrarchs prompts us to inquire about its complex nature and whence the "design" of it all. My guess is—to judge a bit from what Bucklow said of Derges— that he thinks there may be Design; that it is not for the artist to make it; that it is for the artist to seek it out, recognize it when it is there (as Frost had intuited it, too), and to use it to one's advantage in an eternal process of becoming, in a process of reintegration with something more than Self.

NOTE

1 Bucklow's *Between Sun and Earth* is published under the name Christopher Titterington, his adoptive father's surname and the name he used while he was a museum curator. After leaving that profession, he reverted back to using Christopher Bucklow, the name he was born with.

Flesh and Stone

BY JOHN METOYER

Since its beginning, photography's primary function has been to document. Daguerre
documented his studio. Mathew Brady documented the horrors of war. Atkins
documented nature. Hine documented child laborers. Whipple documented the moon.
And Bellocq documented hookers. Everything from mankind's first step on the
moon to my niece's first birthday party has been recorded on film and printed for all
of posterity. Because of this, the inherent perception of photography is that what
we see is real, and thanks to the documentation of children's birthday parties and the
sustained crescendo of public advertising, much of what we see goes ignored.

This is both a blessing and a curse. My occipital lobe has been conditioned to block
out ditech.com ads on the sides of busses. A blessing. The downside is that much
of the controversy surrounding artists such as Sally Mann and Jock Sturges is centered
on the perception that what we are seeing is documentation of an ongoing reality,
as in the realities of war and famine, and not temporary and contrived situations. Sally
Mann's children did not run around all day naked, smoking cigarettes and bleeding.
Fortunately, there are photographic artists who manage to elude the curse of their
medium's inheritance. Brigitte Carnochan is one of those photographers.

Carnochan's work, with its sculptural nature and dreamlike, painterly colorations,
goes far beyond the sense of document usually associated with the photograph.
Though her images are the medium's traditional staples—floral studies, the still life,
and nudes, subjects we have seen since Daguerre and Talbot made their first, labori-

ous, permanent prints—the final product of Carnochan's efforts does not allow the viewer to gloss them over. In fact, many of her floral studies, such as *Tea Rose I* (for images not reproduced in the text, see www.brigittecarnochan.com), require close inspection to determine if what we are seeing is, indeed, a photographic image or an unearthed canvas of Georgia O'Keeffe's making.

Calla Lily V and *Calla Lily VI* have the power to deceive the eye as well. The colors and details achieved in these images are not exactly what one will find when observing a calla lily in nature. Carnochan subtly allows the eye to see what is usually hidden. Laminae, blooms and peduncles become accentuated, deepened by shadowy details. Ultimately, what we are given is not simply a document of what exists in nature but the artist's version of nature—a version that is something other than what the forces of the universe intended her subjects to be.

Carnochan's still lifes embody the flux with which her work ebbs and flows between the real of photography and the artifice of painting. At first glance, *Raspberries*, a small basin of freshly picked berries, looks as if it could be a detail from a seventeenth century Willem Claesz Heda painting. The use of hand coloring gives *Raspberries* the same soft detail and diffused quality of light found in much of Heda's work. It is these exact qualities that provide Carnochan's images with their anachronistic sensibilities. While Heda's subdued tones lock his work in the candlelit world of the seventeenth century, the warm crimsons applied to the raspberries, the rich sienna given to the table top, and the slate gray Carnochan uses for the basin propel her work back into the twenty-first.

Romanticized fruit is not a subject unknown in fine art photography. John Dugdale, Irving Penn, Josef Sudek, the Lumières, Olivia Parker, and a seemingly endless list

of known and anonymous photographers have incorporated fruit into their photographic work. The Carnochan treatment of the same subject matter is quite different. In *Two Pears*, instead of idealized perfection, we are exposed to all of the pears' blemishes and flaws. Even with all of their imperfections made obvious at the hand of the artist, these *Two Pears* are the most appetizing I have ever seen. The artist's choice of film, paper, and palette has altered mundane produce into foodstuffs of the gods, and we the viewers, mere mortals, are left to gaze upon these forbidden delights with the burning temptations once felt by the likes of Eve.

Equally appetizing are Carnochan's nudes. Of course, when the phrase "hand colored nudes" is mentioned, most thoughts turn to Jan Saudek; however, in Saudek's work, hand coloring takes on almost obscene proportions. He gives garish and impossible coloring to scenes of Bosch-like grotesqueries, drawing the viewer into a world of absurd eroticism, which should be reserved for pornographic nightmares of the most disturbing nature or, perhaps, the second and third circles of Dante's Hell.

Carnochan does not use photo oils to inject the fiery passions of life into her human subjects as Saudek does. An elaboration of how polarized these two artists are in their imagery and technique can be found in Carnochan's *Tutu*. This is an image reminiscent of Degas's *Dancer Adjusting Her Slipper*. As in the Degas, vitality exists in the physique of Carnochan's dancer, but the choice of suppressed palette used in *Tutu* and so many of her other images marbles the skin of her subjects with delicate, blue veins, trapping these human forms in an existence that is somewhere between stone and flesh. *Tutu* is the embodiment of all that Carnochan does. She has created a beautiful photographic image encompassing the qualities of a painting, and just as the appearance of her still lifes fluctuates between painting

and photograph, her figurative subjects, especially the one found in *Tutu*, vacillate between the presence of life and the lifelessness of finely sculpted stone.

We find some of the same in *Nude with Raised Arm* in its color version that can be seen on her website. Here we have hand coloring so subtle and balanced, the print appears to be chemically toned. No toning agent, not even in the hands of such skilled masters as Keith Carter or Tom Baril, can possibly produce the subtle hues found in this image. In its original black and white version, published here, it takes on a different, more sculptural power. Carnochan's statuesque figures, with their hidden faces and classical poses, find kinship in Frank Eugene's *La Cigale*, Robert Demanchy's *Struggle*, and Edward Steichen's *In Memoriam*. Her connection with these artists brings her in sharp contrast with most of what we see in Saudek's work. Instead of *Venus of Willendorf*, what we find in Carnochan's *Nude with Raised Arm*, as with much of her figurative work, is *Aphrodite of Melos*.

The comparison of Carnochan to the classical Greeks goes beyond the sculptural nature of her work. She, too, is in pursuit of an ideal—a personal ideal. Her choice of models is a substantiation of her pursuit. These women are dancers and practitioners of yoga, individuals whose combined focus is on the physical, spiritual, and intellectual, the three elements at the core of our strengths and vulnerabilities. *Nude with Netting* is a culmination of this and all that Carnochan's work represents. *Nude with Netting* is *Nike of Samothrace* made flesh, wingless and intimately vulnerable in her mortal incarnation. The normally cold, statuesque power of the classic torso turns seductively warm without losing its potency. She, like all of the subjects in this body of work, is transformed from the mundane of everyday to the transcendent at the hand of Brigitte Carnochan.

Phantoms

after a photograph by Julio Pimentel

BY SUSAN LUDVIGSON

The way we spend our days
is the way we spend our lives.
—ANNIE DILLARD

We are so easy to fool.

Dress an angel in black and he seems

just another traveler waiting for a bus.

We forget that we too are in disguise,

wearing our heaviest days

until they become us.

Dry bread, undrinkable wine

in a dusty corner—

what we see, what we expect

to see.

Since we first discovered

the door to the cave, the last

we will enter,

we have misunderstood.

We have not noticed the robed figure

losing his head to radiance.

Nor the one who's come to sit

beside us on a bench,

no yearning in his posture,

bench and body

drenched in gold—

startle of breath

on our hair, whispered

intimation: here,

here is the shimmering world

within the world.

Friends, let us not be immune

to delight.

Boy Reading

inspired by a photograph by Julio Pimentel

BY ANN PATCHETT

There are always too many books. I put them on the shelves alphabetically, their
spines neatly aligned, but then more come, and I force someone new into the
over-crowded neighborhood, books shoe-horned in so tightly I must remove half a
shelf to pull one free. And when there is not enough room to squeeze in a single
human hair, another book comes, the same first letter of the last name. This book
must go in the exact spot as the last one and no amount of physical strength could
make that possible. Regretfully, I lay the book on its side on top of the space where
it belongs, a wait list for a place on the shelf. Maybe something will open up.

When I first bought these bookcases there were open planks of cherry wood. The
bottom shelves were empty. I bought so many bookshelves that I knew, finally, I
would have enough. They would never be filled. It seems like a lifetime ago. I put a
framed picture of my dog between *Rabbit, Run* and *Rabbit Redux*. There was a
shimmery blue butterfly between two pieces of glass and a small rabbit carved out of
soapstone tucked between Joseph and Margaret Mitchell. But none of these things
lasted. One by one I pulled the decorations off to make room for books. They were
book shelves, after all. There could be no question about my priorities.

I purge the shelves regularly. I take out the books that I read and didn't like and the
books that I know I will never read and I move them to a stack on the floor at
the end of the bookcases. These books I will get rid of when I hear about the right

kind of book drive. I want them to find a good home, but it can't be my home anymore. There are people who guard their books. They make you sign a card when you want to borrow one in a friendly way, as if they were a library and must observe certain strict regulations. I am glad to loan the books I have and secretly I am glad when they don't come back. In the time they were gone their space is always taken up by someone else, another book I haven't read. If it happens that I want a book that never came back, I can buy it again and again. It doesn't matter what cover is on my copy of *Sense and Sensibility*. I can always trust the words will be the same.

There are certain copies, of course, I would be sorry to see go: Berryman's *The Dream Songs* from college, a different color paperclip marking all my favorite poems; Ray Bradbury's *Dandelion Wine* with a note on the first page, "To Ann, for your sixteenth birthday, with love and respect for all the years, past and future. Much love, Mother"; *Zeno's Conscience*, because I really mean to read it someday; a leather bound, illustrated copy of *The Robber Bridegroom* signed by Eudora Welty. That would be the book I would save if the house were on fire.

Of course, even though I have too many books, there are the books I must have many copies of. It would be pointless to have only one copy of *The Good Soldier* because it is perfect for every occasion. A nearly forgotten birthday? *The Good Soldier* in gift wrap and satin ribbon. Going to someone's house for the weekend? *The Good Soldier* in a

bag next to a bottle of wine. Your own houseguest leaving with nothing to read on the plane (as nothing sends me into a panic quite like the idea of having nothing to read on a plane), wait, here, take this book. I could never have enough copies of *Selected Poems* by William Carlos Williams or Scott Spencer's *Endless Love* or Elizabeth McCracken's *Niagara Falls All Over Again*. They walk out of here in the night. They are the door prizes for my most casual visitors. I once had a new bookshelf delivered and sent the man who hauled it up the stairs home with a copy of Colson Whitehead's *The Intuitionist*. I was happy to. I buy that book in bulk.

Sometimes I think about building a room with all the books I have, not to build a room for the books, but make the walls by stacking books together. I will slip a slender Nathanael West in between the hulking Robert Musil and the short stories of Nabokov to block out the wind. I will make my furniture from books, shape a comfortable reading chair from the well worn pages of Raymond Chandler, an ottoman from *Moby-Dick*. And when more books come I will read them and then build on additions. The walls will be filled with millions and billions of words, sleeping in their hives like winter bees, the soft droning of their intelligence lulling me towards dreams in my bed made of books.

Even though it might seem as though my books are doing nothing but gathering dust and squeezing me out of the house, it isn't true. They're calling to me all the time. If a book was capable of having a want, it would want to be read. All the more reason to loan them out to people who will loan them out to other people when they're finished: shouldn't we meet the needs of the book? As soon as I start one I have my eye on another. I stack them on my bedside table and beneath my bedside table, rearranging them periodically as I reassess their priority. My dream is always to give in to them, to dive into them.

There is nothing sweeter than to wake up, turn on a light and read, to slip from one world of dreaming and into another. I long for colds that will keep me in bed for days. I long for snowstorms that will hold me in the house. I would starve to death long before I ran out of things to read. People ask me what my hobbies are. Do they mean tennis? Collage? I read.

I read at the breakfast table and then move to a chair. I read at my desk and on trains and in the countless waiting rooms that connect my days. I would wait forever if the book was good. I do not mind when people are late or when I am stood up altogether. I am reading. Give me a trans-Atlantic flight in which the person in the seat beside me never speaks. I will just be turning the pages, safe in the knowledge that I do not have to fix dinner and the phone cannot possibly ring.

There are so many books, sometimes I panic. There are the books that came out this week and I want them because they are exactly of this moment. There are books from last year's moment I never got to but have not given up hope on. There are books I simply missed along the way. I didn't read *Portrait of a Lady* until last year. I stake out the high school summer reading tables at the bookstore where the holes in my education are pointed out with a bright light. I try to fill them in, one book at a time. I never forget about the books I want to re-read, which is every book I have ever loved. Isn't it time to read *Anna Karenina* again? And what about Dickens? I have a complete set (I have a weakness for complete sets, encyclopedias, nature guides with glossy pictures, dictionaries, and all reference materials) but I've only read a handful over the years. Is today the day to start *Bleak House*?

It might be.

Find whatever corner you can, settle for the available light. The world you are sitting in means nothing. It's the world you are going to, the one you are holding in your hands, that will be your salvation.

The Genius of Julio Pimentel Maciel

BY JOHN WOOD

Julio Pimentel is a fifty-two-year-old, unknown Brazilian photographer and musician who lives in the southern state of Rio Grande do Sul—over 3000 miles from Rio de Janeiro. He has an old camera, sometimes can't get the papers or chemicals he needs, and often has to travel to Punta del Este in Uruguay to play Latin jazz so he makes enough money to help support his family and his art. And a very great art it is! (For additional images, see http://www.pimentelmaciel.hpg.ig.com.br./index.htm)

Pimentel's photographic vision is among the most remarkable I have ever encountered. I have seen over a hundred of his images and each one has startled and moved me. Selecting only six to include in this issue of *21st* took me hours. I regretted leaving out his nudes, his bowls of flowers, his gauchos, his guitar makers, and on and on.

I have corresponded with him for quite a long time now. His letters are as remarkable as his art. His English is not perfect—and he frets about that, but it richly captures something of this artist I have come to admire. Here is a letter he wrote me a few years ago:

> hy John, what can I say about me? I born in bage nearest the
> border line with uruguay. I grow in a farm of my father, I just
> came to the city when I was 10 years old to study (the time
> run), I study veterinary but I didn't get the diplome, my head all

the time was thinking in photos and music, so I decide to do what I really want, and I love what I do, I am married, I have two daughters (18—19) and I am a grandfather, and I have 49 years old (what boring speak about ourself),, but,, I begin with the music when I was 15, I can play nylon guitar (my instrument)..bass..piano..drums..percussion..and with photography I began when I was 18, I never study photography,,,and music too,,I had to learn alone, maybe one day I start to study...I dont know...its difficult for me to make some money with the fotos I like, sometimes I speak with myself and I say,,its not a hobby for me the fotos,,,,look and see,,,,the photographyc situation teatched me a lot of things,,,to see the natural atencion growining in you,,, to see the spiritual situacion with no misterys,,,to be here and now,, this things I learn making fotos, one day I wrote this (I dont know thats correct in english,,but,,)the photo is the music dressed of light....and music is the photo of the sound for eternity ,,,, now I stop to write you because I wrote only with one finger,,and this finger now have pain...you never read Krishnamurti?? please try. I hope good. all the best....Julio

I know that Julio will probably be bothered that I included his own words as he wrote them, but I found them so fresh, so honest, so open that I didn't think it would be right to manipulate them, especially since his words are so perfectly clear. I wish I could express myself so well in Portuguese, a language in which I know a single word remembered from a holiday once twenty-five years ago. But it is the single best word I could say to an artist of Julio Pimentel's strange, beautiful, and sweeping vision: *Obrigado.*

Catany in the Heart of His Preferences

BY PIERRE BORHAN

Born in 1942 in Majorca, the largest of the Balearic Islands, Toni Catany is the first representative of the generation of the transition that contributed to the passage from General Franco's Spain to that of democracy. If the taste for the arts, in particular the plastic arts, was somehow innate in this only son of a rather modest family, the young boy soon proved his determination, even before freedom succeeded the dictatorship, for becoming a photographer, and remaining one.

From 1957 to 1963, when he was studying Chemistry, which he did not complete a degree in, he took correspondence courses in photography to acquire that knowledge he has not stopped putting into practice—from the shot to the expert production of prints. Catany's genius is even more remarkable considering that Franco, in power in Spain from 1939 until his death in 1975, did not consider photography one of the fine arts, and schools and universities between 1960 and 1970 did not include Catany in their programs, museums did not offer him exhibition space, and no bright future could be promised this amateur who had the temerity to see photography as a profession and an art.

But, beginning in the 1970's, the Spanish photographers of the generation of the transition progressively broke with their older reporters who were prohibited from free expression, and with illustrators who did not have the ability or boldness to innovate. On the occasion of trips to France, in particular to Paris and Arles where each July the Rencontres Internationale de la Photographie takes place, they bought

books nowhere to be found in Spain, and they met other photographers, historians, curators, gallery owners, and critics. And following the Franco era, they soon found the means of personal expression.

After the death of his father in 1963, Catany—21 years old and now settled permanently in Barcelona— began to discover himself. His preferences took shape, his convictions manifested themselves. He liberated himself from the yoke of Catholicism and its morality, in which certain prohibitions seemed unjustifiable to him. He rejected social fatalism and accepted himself as a photographer without being frightened of the difficulties he would meet. Immediately from that moment, for about fifteen years, while working for journals and magazines, he let himself assert his mental, sensual, and emotional universe: he matured. Little interested in theoretical debates, resistant to political and social intrigues, he was privileged in friendship, and the pleasures that are given by literature (Proust, Montaigne, Cernuda), by music (Mozart, Chopin, Lecuoña), by painting (the Flemish, Matisse), a meal, a landscape, or a meeting with a friend. He intuitively learned to nourish his photography with his sensations and his emotions, as much as with the lessons that he took from the history of art. He knew how to profit more and more from what aroused a resonance in him.

In 1976 Catany bought an old camera at a flea market and learned to make calotypes—Fox Talbot's original process from the scientific and magical beginnings of photography. This work announced the genres he would devote himself to: the still life, the landscape, the nude, and the portrait. He turned his back on photojournalism, promotional photography, and fashion photography. He had to be independent, and his calotypes revealed his first references, pictorial as well as photographic: the young Picasso, Edward Steichen, Cecil Beaton.

Shortly afterwards he dared to use color in producing still lifes and rapidly excelled in this neglected genre which he regenerated in transmitting subtle waves of the heart. His still lifes are real moments of illumination, sovereign intuitions, and with them, Catany inscribes himself in the tradition, was innovative as a subtle colorist, and claimed his individuality as an artist. He enriched a language which permitted him to expound his peculiarity as well as feel and make someone else feel the lasting pleasure of an image. The still life genre suited and still suits him well. From the early 1980's, his still lifes made him known to the wider public and made him recognized by his peers. "I breathe your soul to the odor of lilacs" said poet Guillaume Apollinaire to Lou. Toni Catany, the Majorcan, creates a photographic language in unison with the language of flowers.

Most of his still lifes present flowers he has chosen either by his taste, by place, by climate, or merely by the state of his soul, by his inspiration. Wildflowers, garden flowers, or ceremonial flowers freshly opened, in full bloom, or dried—or fruits, fleshy, appetizing, or even rotten, and found objects, those memories of family that die in certain hands to be reborn in others, cloth, embroidery made of love, of hope, or of melancholy, ordinary glasses or precious ones, crystal vases, fine porcelain, rustic pottery. But breaths, elixirs of the invisible, predominate in his compositions that are only still lifes to those that look at them without looking inside them.

Composed by a recluse sensitive to correspondences, in Baudelaire's sense of the term, they are rich in their secret relations with deposited things of human affections, and with musical, literary, pictorial, and photographic works that arouse echoes in him. Think of popular Neapolitan songs, of Edouard Manet, of Luchino Visconti, of Josef Sudek. Such presences do not reduce to things visible. These allusive images are altars of meditation and dream. The good fortunes of the photographer's style

bring to them what adds a perfume to a silhouette, a liqueur to a dessert. It is because they allow him to make his personal emotions shine through that Catany makes still lifes similar to no one else.

At the same time he continues to approach the secret of things and follow the precept of Sudek: "Do everything thoroughly, do not hurry, and do not worry." Catany discovers year after year the Mediterranean shores that are like the crown of his native island. He familiarizes himself with this cradle of civilization, from the peak of Athens to the radiance of Rome, from the builders of Abu Simbel to those of Petra, and mixes the lessons of the past with the pleasure of the present. Antinous converses with an Adonis met in a souk of Cairo or Istanbul. Catany tastes the delights and other sensual pleasures of art and life, of archaeological sites in a spice market, of a Renaissance palace in a marine landscape, umbrella pines, and the shimmering sea, those of Egypt, Turkey, and Greece where he abandons himself to seductions, to ravishments: he is at the most close to himself.

In the course of his trips, if he admires some of the great Greek sculptors such as Myron and Polyclitus, he praises in his turn the human body. Since 1987 he has taken dancers he sees or sometimes young men sent to him by friends as his models. They are like statues to whom he appropriates beauty. When their anatomy is not ideal, he frames only the most beautiful part, or he masks the flaw with a shadow: the chiaroscuro then becomes the accomplice of the illusionist who offers an eternal aura to mortal beings and the imperfect. He sees them as diverting gods of the human condition. He confers upon these "objects" of worship a part of favorable unreality to their own radiance. He, like Michelangelo in his time, also knows the delight of a skillfully innocent eroticism.

The statue of an athlete in Greek art was less a nude than a body with the presence of the gods in it. The male nudes of Catany have a similarity with such statues. Even if they are seductive, idealization prevails over the seduction. Divine fires burn in their flesh and lend them the admiration of mortals. Certain ones among them are gifted with a sensitive sweetness that lets them confuse the quest for Platonic beauty with a quest for love. "To photograph is to appropriate the thing photographed," wrote Susan Sontag. The artist—whose sensory vision is that of a visionary—dilutes his presence in that of the transfigured model. It is as much in his spirit as in his eyes that he gives birth to his uncommon nudes that he puts the finishing touches on equally with his hands, in his darkroom, and particularly in toning the prints with selenium. But the spectators can also appropriate the beauty of these bodies without identities and appreciate them. Certain people can see them as desirable, voluptuous, tender, and they can be delighted that Catany venerated the worship of Eros with representatives of the "neglected sex," as Jorge Lewinski terms it in the chapter on the male nude in his book *The Naked and the Nude*. Catany photographs without shame the attributes of virility, remembering William Blake's definition in *The Marriage of Heaven and Hell* of "the genitals" as "Beauty."

These nudes make Catany an eminent representative of a Spain freed from the influence of an exacerbated Catholicism and a severe political censure that under Franco prevented all artistic flowering. They attest that Catany is a carnal mystic and that he can give an aura, by his care, to a sacralized body.

These nudes reveal relationships between Catany and some of his best predecessors, such as Fred Holland Day, admirer of the Greek genius, and the erudite speaker Bernard Berenson, the well-known historian of the Italian Renaissance. Day, who introduced sensuality into the photography of the male nude, thought that the

Imaginary fertilizes images and that Enchantment occupies in art the role that love plays in life. One also thinks of Frank Eugene who retouched his negatives and prints, corrected the details and suppressed the imperfections; and of Minor White for whom corporal beauty, above all, resided in the resonance that it aroused, who eliminated all décor—landscape or interior—to better concentrate on the carnal being; of Eikoh Hosoe whose photographic successes were followed by his books *Man and Woman, Embrace*, and, even more so, *Killed by Roses* where the photographer and his model, Yukio Mishima, set themselves in the world of idols; of Duane Michaels, author of *Real Dreams*, whose fictions harbor one part of the invisible and show at what point the photographer can depart from "the ocular function of photography" to make the emotion of one soul pass to another; and lastly, of Bill Brandt whose plastic sense Catany does not stop admiring. The homogeneity of inspiration and style in *Sominar Déus*[1], the album which assembles for the first time an important choice of Catany's nudes, published by Lunwerg in 1993, is as remarkable as that of Brandt's *Perspective of Nudes*. Like those of Brandt, the nudes of the Majorcan are outside of time and outside of all society: incarnations spared by the pains of living and emotional heartbreaks. Detached from their personal history and all factual history, they have no place but in that of civilizations and in that of arts.

If Catany makes us reach his world, he keeps himself from unveiling his personal relations, which remain discreet, and from photographing his own embraces. He confers thus on his works a dimension that offers no exhibitionism. Preferring the suggestion of the description, he modestly stands apart from his work but in quest of himself. It is in sensitivity that secrets exchange themselves.

In 1994, he decided to develop a personal work based on the face. He opted for color and chose Polacolor 809 film that transfers at the time of development onto

one hundred percent cotton paper. He knew that his timidity prevented him from asking certain potential models to pose for him, but he counted on the welcome help of friends and on favorable circumstances. Portraits followed from Barcelona (Olivier, Ricard, Carole) and especially in Cuba (Changó, a sheer masterpiece, Alexis), in Ghana (Kumasi, met in an open-air market), in Venezuela, in India.

Catany did not choose the models for their fortune, their celebrity, or their place in some pantheon, but for their pride or their humility, their physical health or their posture. "To make a good portrait, it is necessary that I love something," he says. Since he photographs *in situ* or in his studio, he considers the human more than he stares at it.

All portraiture poses a recurring question: who is portrayed, the photographer or the model? The accomplices of Catany, whether their faces are stately, thoroughbred, poverty-stricken, worn by suffering, or spared the trials of life, have origins socially close to his own, but Catany does not strive to make portraits reducible to self-portraits. He searches more, among other things, for difference rather than similarity. Richard Avedon said that his portraits are "more a definition of myself than of someone else—a portrait of what I know, what I feel, what I am afraid of." The only face that obsesses Avedon is the face of death. Bill Brandt calls attention to his portraits by the dramatic intensity that he confers upon them, characteristic of his somber vision and of his taking hold of models that do not know how to resist him. In Catany, the seizure is less pressing and the affirmation of oneself less condensed, more radiant. What makes each of his models, often anonymous, become a subject of photography is due to at the same time the model (his beauty, his happiness, his ability to seduce and to move…) and to the photographer, to his power to guess, to imagine, to transform the lead into silver or gold. Changó, Kumasi, and Alexis would be

without a doubt surprised to see their image, once the transfiguration is completed, rooted out as if by magic from ordinary life, and celebrated.

Like the model, the photographer, who excludes the surroundings and concentrates upon the face, the sesame of the soul. In these Catany can only see the faces which "speak" to him, move him, delight him, and permit him to create emotional, sensual echoes. He knows that he can preserve only one vision, otherwise an illusion. Master of molting, he offers a manner of dreaming saving each time the mixed faces, real or imaginary, of the two protagonists.

The portraits of Catany make his oeuvre with *his* nudes, *his* still lifes, *his* landscapes, and they converse with those of the Byzantine icon, of the Flemish masters, of Antonello da Messina, of Giovanni Bellini, and with those more recent of Paul Strand. The author of *Un Paese* authenticates himself also soberly and naturally as the human evidence of each of his models. The two photographers share the same universalism and an innate disposition to pacify life which impresses itself in art. Nevertheless the admiration that Catany brings to past artists does not incite him to repeat their creations. His portraits tower neither in the past nor in the present, but in suspended time. They constitute an apology of the human that must be again and always helped to affirm itself in the order of the ideal.

Strengthened by the lessons of his fathers in photography, Catany enriches a history begun well before the invention of his favored medium. A great expert of ancient techniques, and an experienced user of new ones when they reinforce his gifts, he visualizes his mental universe that he filters poetically, and his attachment to the world, rather sensitive and emotional, without exhausting the mystery.[2] His work is born in the heart of his preferences.

NOTES

1. The principal books dedicated to Toni Catany are *Natures mortes* (1987), *La meva Mediterrània* (1990), *Sominar Déus* (1993), *Obscura Memòri* (1994), *Toni Catany, Fotografies* (1997), and *Toni Catany, l'artista en el seu paradís* (2000) published by Lunwerg Editores, as well as *Toni Catany, Photographies* (1993) published by Paris Audiovisuel.

2. The work of Toni Catany has been presented in public in more than a hundred personal exhibitions (Spain, France, Belgium, Switzerland, Italy, Germany, Great Britain, Tunisia, Morocco, Argentina, the United States, Japan, etc.). His first retrospective was presented in Barcelona in 2000 by the National Art Museum of Catalonia. Toni Catany is represented in the United States by the John Stevenson Gallery in New York.

Translated by Dafydd Wood.

Holding Venus

after a photograph by Keith Carter

BY DANIEL WESTOVER

Long spokes of sun trace scrap piles—his routine
of switches, rivets, spikes, and rail repair—
and shadows follow, rinsing the lot clean
of his habit; blues and grays cool the air.
A boxcar carcass, dumped near the depot,
molders in the breeze; by its gutted husk,
a strip of tin reflects the pulsing glow
of Venus hovering in low-lit dusk.

Like a small, glass flame she shines, and he turns
his Coors bottle, angles it so he can hold
her fire in a muddy foam, swirls her burn
in a slow churn of sepia and gold.
His father, who taught him lantern signals,
how to fix air-coupling, knuckle, and clutch,
also taught him stars, and above the stalls
she shines familiar, close enough to touch.

He sets the bottle down and lifts his palm
slowly into the windblown dust, then takes
the burning pearl on his callused hand. Calm

and still, he forgets hinges, swivels, brakes;

he carries her radiance till he is far

from the day's grit, alone with a goddess

that glows bright as a firefly in the jar

of coming night. Into the wind's harness

she rolls back, slides from extended fingers,

and settles into twilight's charcoal fade.

He bends, picks up his bottle, and lingers

to watch other lights brighten the shade;

they are rising now, flickering into sky,—

Mars, Alcyone, Vega—filling his heaven

with shimmer and glint, and the freight yard lies

in silence, beneath what he's been given.

DIMITRIS YEROS

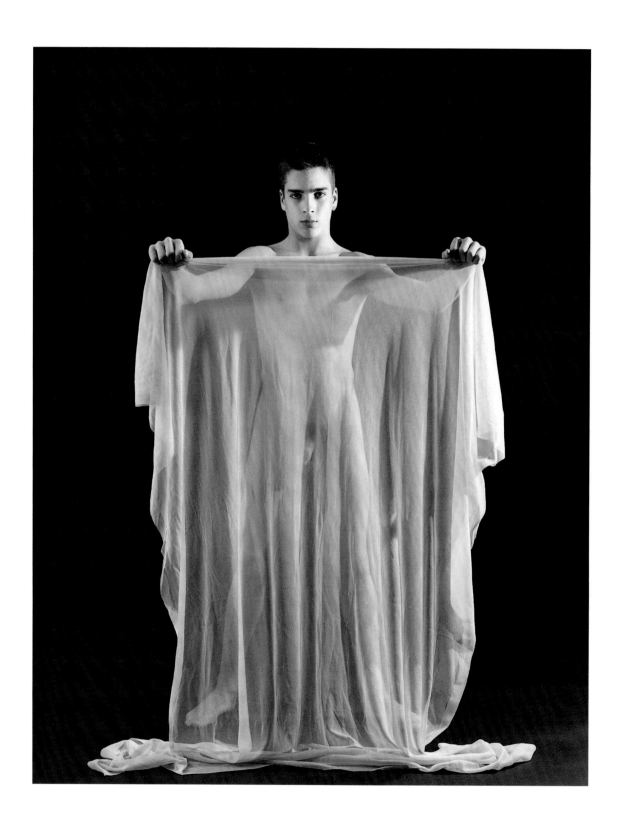

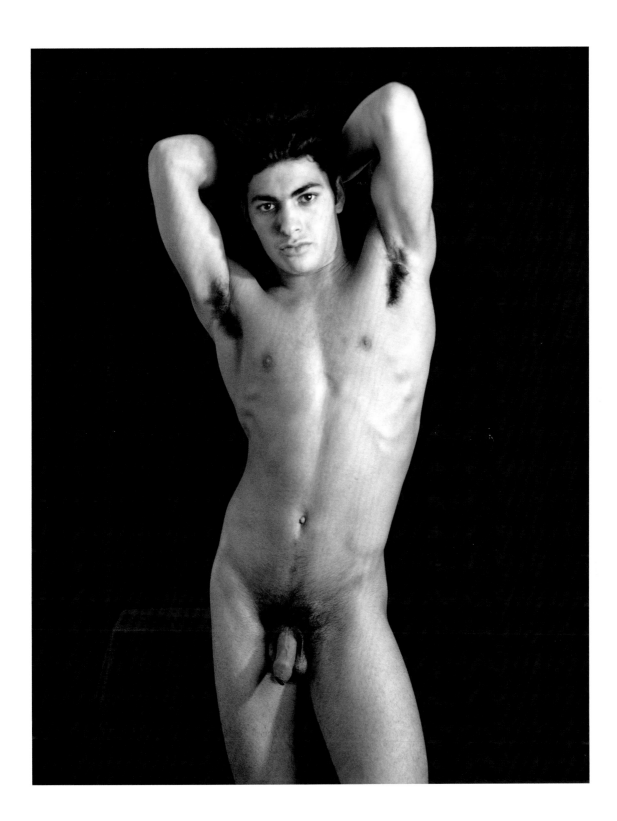

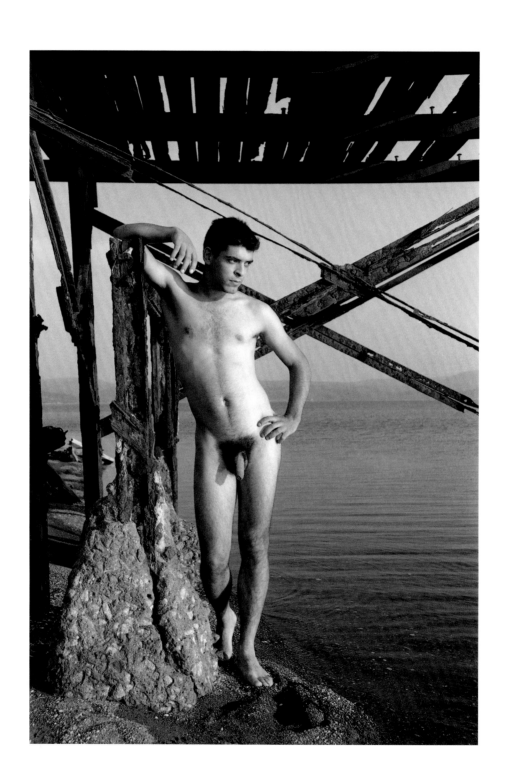

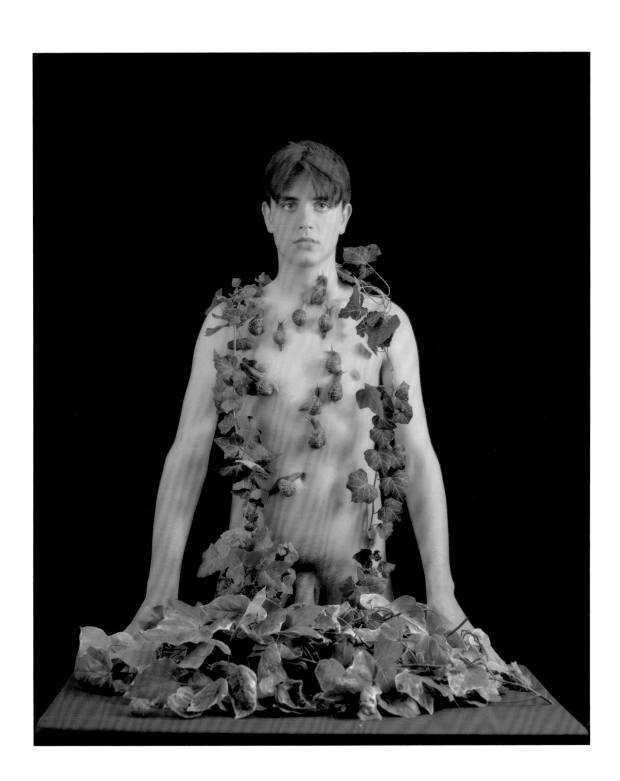

JAYNE HINDS BIDAUT

Delicate Drape, Leda

The Caress

Casmerodius albus: Common Egret

Bubulcus ibis: Cattle Egret

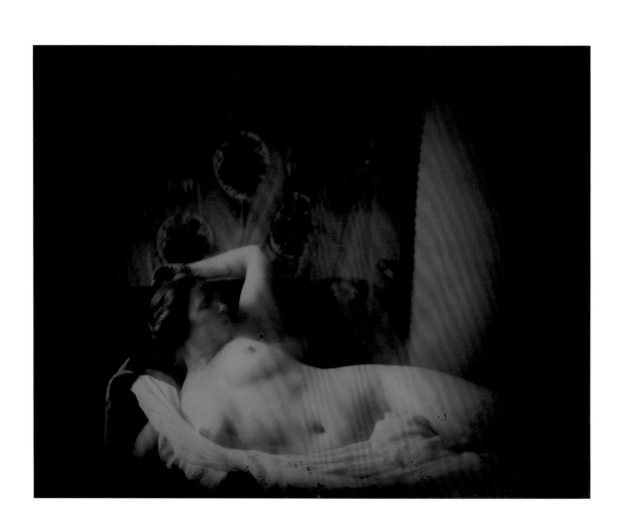

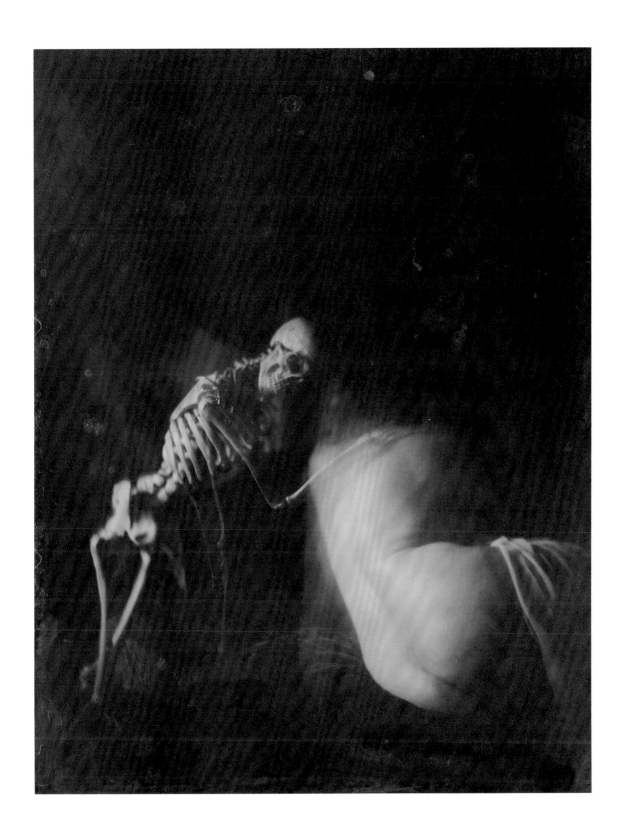

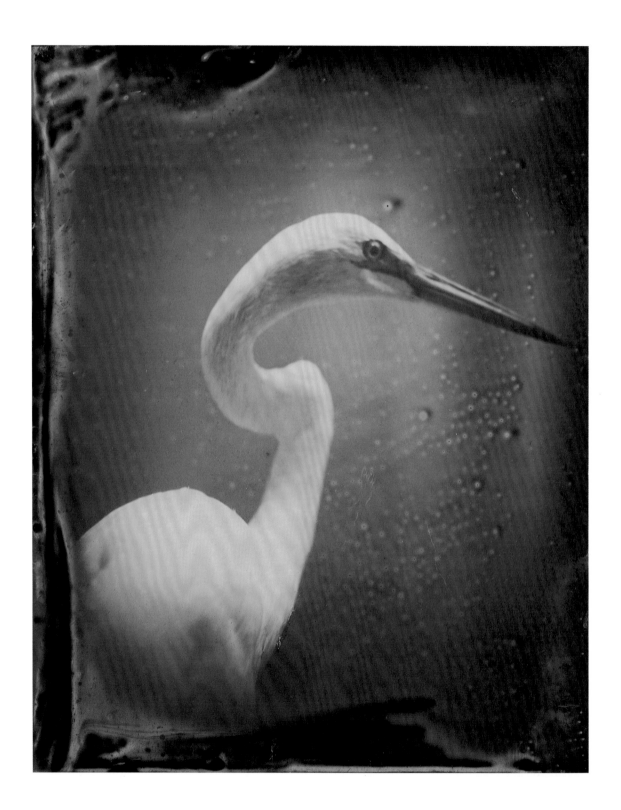

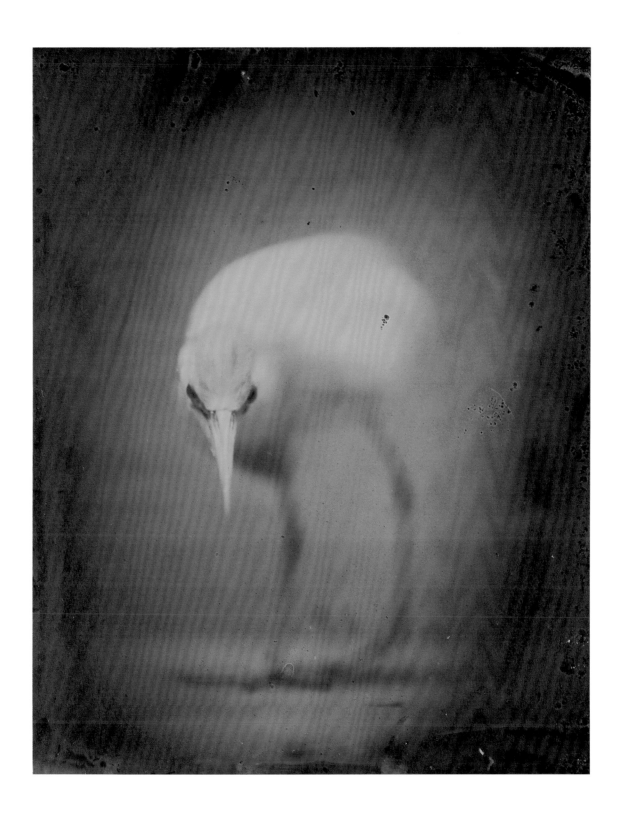

CHRISTOPHER BUCKLOW

Guest (S.P.)

Tetrarch (Glastonbury)

Tetrarch (C.B. & B.B.)

Magnetic Mirror

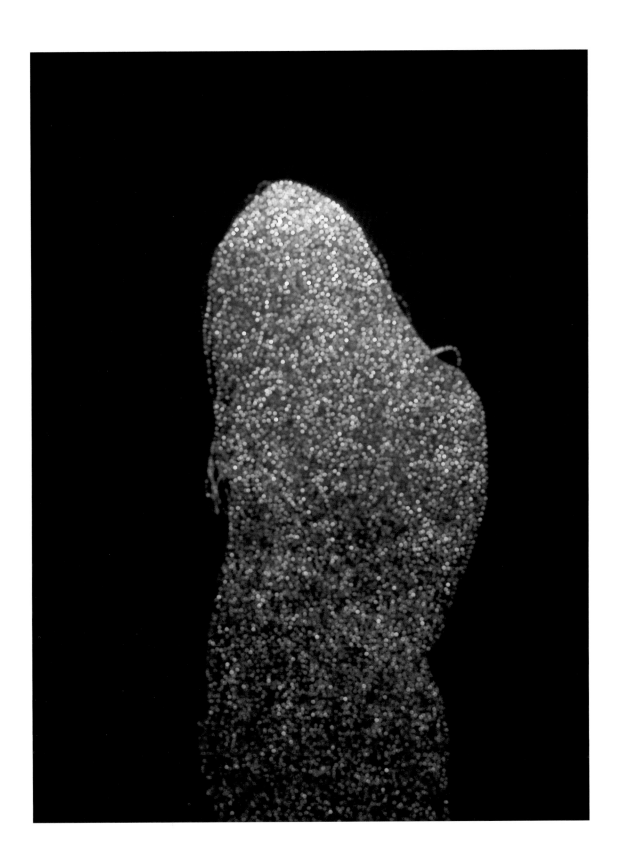

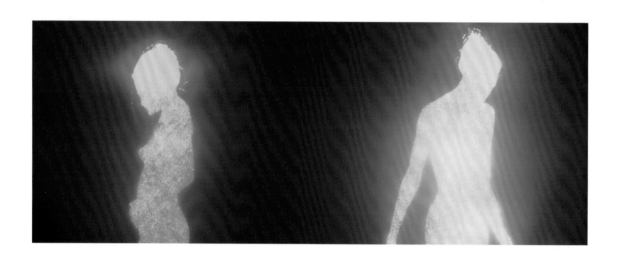

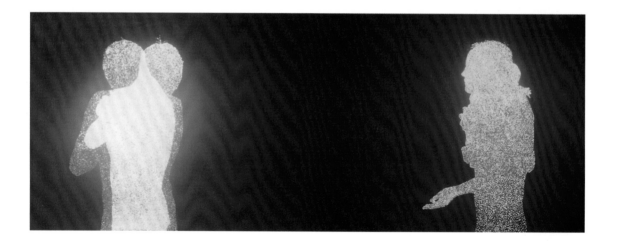

BRIGITTE CARNOCHAN

Nude with Raised Arm

Two Pears

Nude with Netting

Calla Lily VI

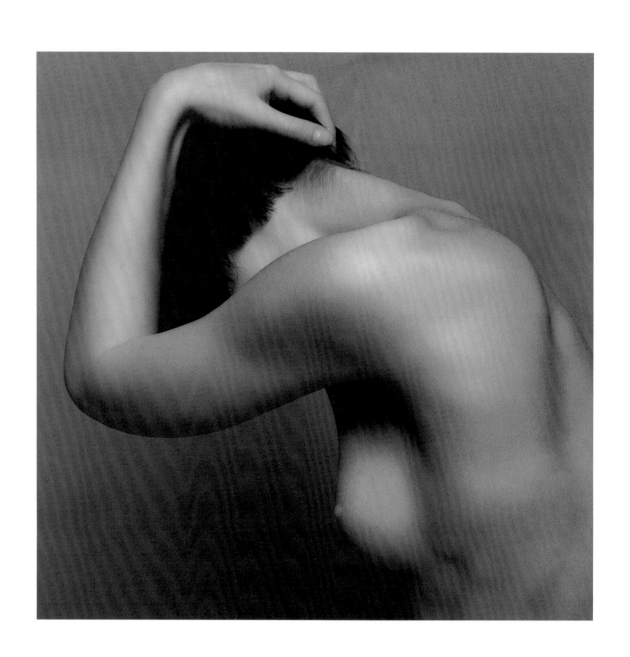

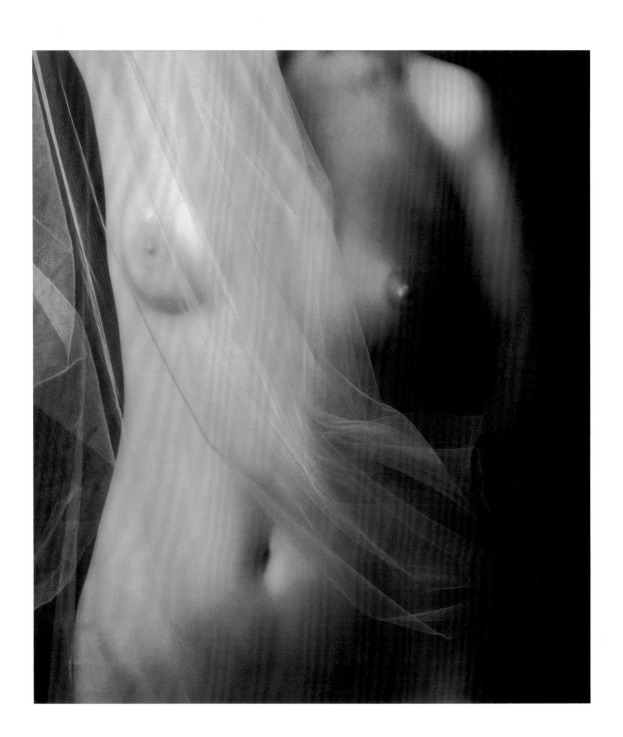

JULIO PIMENTEL MACIEL

Still Life with Armadillo

My Real Dream

The Bottle

Five Phantoms

Boy Reading

Clocktime

TONI CATANY

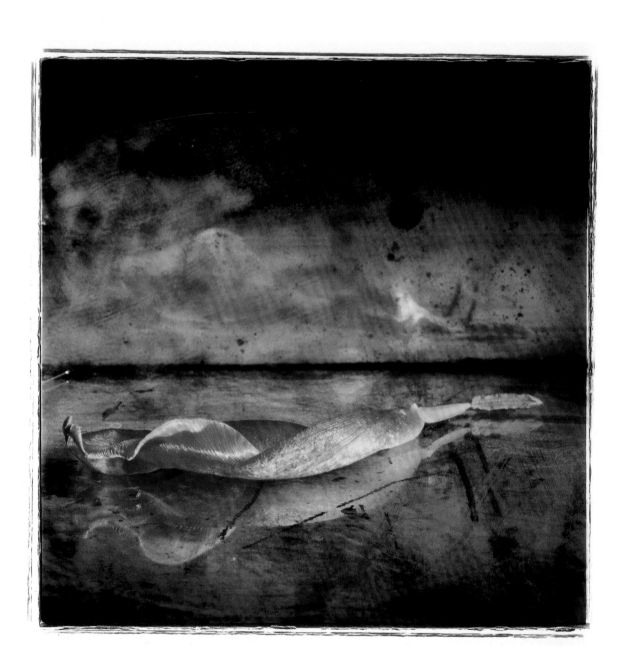

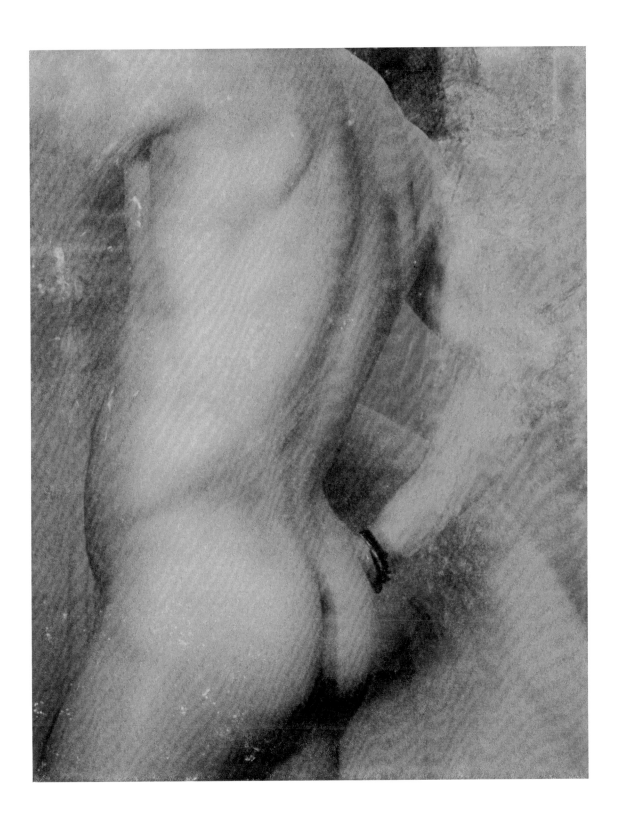

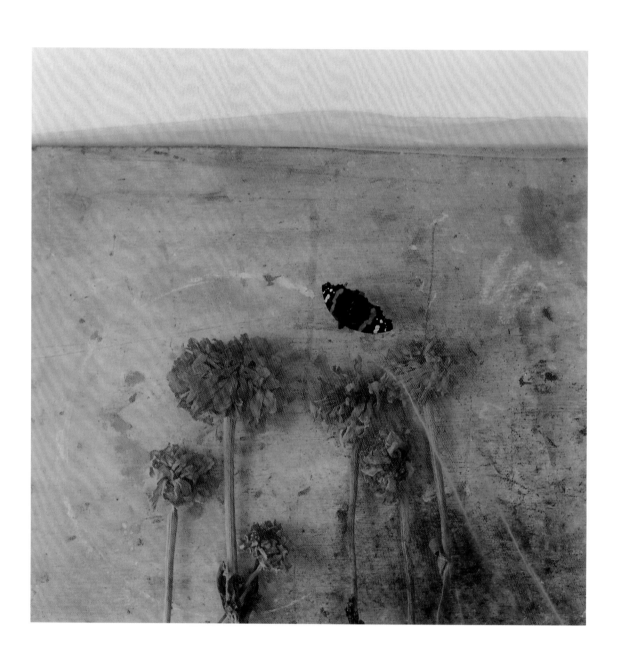

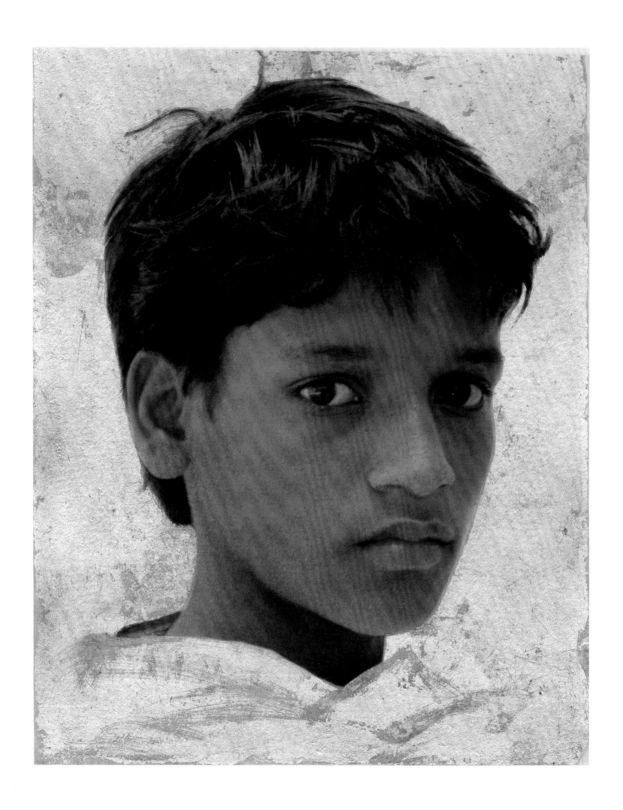

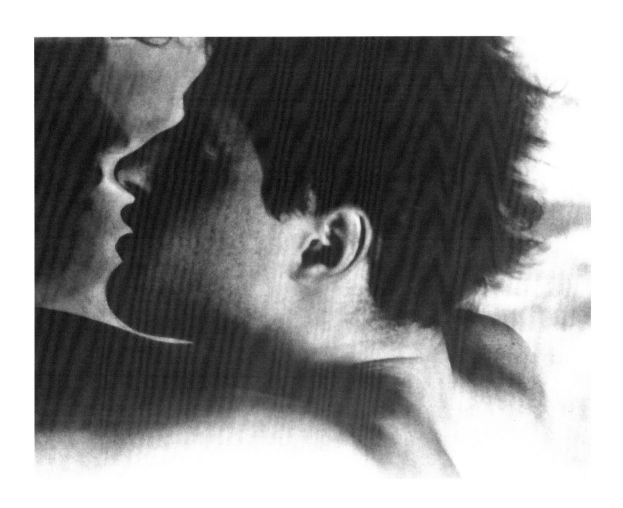

Notes on Contributors

EDWARD ALBEE is one of the most distinguished dramatists of the twentieth century. Among his many awards are three Pulitzer Prizes, a Tony, an Obie, a Gold Medal in Drama from the Academy and Institute of Arts and Letters, a Kennedy Center Lifetime Achievement Award, and the National Medal of the Arts presented to him by President Clinton.

ANN BEATTIE has published seven novels, most recently *The Doctor's House*, and seven collections of short stories. She has won many awards for her writing, including a PEN/Malamud Award for lifetime achievement in the short story form.

PIERRE BORHAN is France's leading photographic critic, Director of the Mission du Patrimoine Photographique of the French Ministry of Culture, past co-editor of *Clichés*, and author of many books, including *André Kertész, la biographie d'une oeuvre*.

ROBERT OLEN BUTLER, author of ten novels and two short story collections, won the Pulitzer Prize for *A Good Scent from a Strange Mountain*. His "Severance: the mosques of Bani" is the beginning of his next book, a collection of the final thoughts of decapitated heads.

MORRI CREECH, author of the prize-winning book of poems *Paper Cathedrals*, is the recipient of several major awards for his poetry, including a Ruth Lilly Fellowship and the Wick Prize.

ANNIE DILLARD, poet, non-fiction writer, novelist, and critic, won the Pulitzer Prize for *Pilgrim at Tinker Creek*. She is the author of many others books, including the

very well-known memoir *An American Childhood*, and she is the recipient of many other awards. In 1997 the EarthLight organization named her as its first living EarthSaint.

FANG JING PEI, author of *Treasures of the Chinese Scholar*, is one of the great authorities on Chinese art. He is also an M.D. and a psychiatrist, and he has written books on Chinese medicine and the Chinese interpretation of dreams. A new book, *Symbols and Rebuses in Chinese Art*, is forthcoming.

LEE FONTANELLA is one of photography's leading critics, the premier historian of Spanish photography, and the author of many books, including the prize-winning *Photography in Spain in the Nineteenth Century*.

BRAD GOINS, Beckett scholar and authority on contemporary classical music, is a free-lance journalist and cultural critic.

PAUL LAROSA, a photographic book dealer and one of the most perceptive writers on contemporary photography, has previously published in *21ST* and elsewhere.

SUSAN LUDVIGSON, one of the country's best poets, recently published *Sweet Confluence: New and Selected Poems*. She is a recipient of Guggenheim, Rockefeller, Fulbright, NEA, and Witter Bynner grants and fellowships, and she is Poet-in-Residence at Winthrop University.

JOHN METOYER, a well-known and highly respected contemporary photographer, is also a poet who holds a Master of Fine Arts degree in creative writing and teaches in both the English and the Art departments of Harold Washington College in Chicago.